O

David Seymour (Chim)

by Tom Beck

VISUAL & PERFORMING ARTS

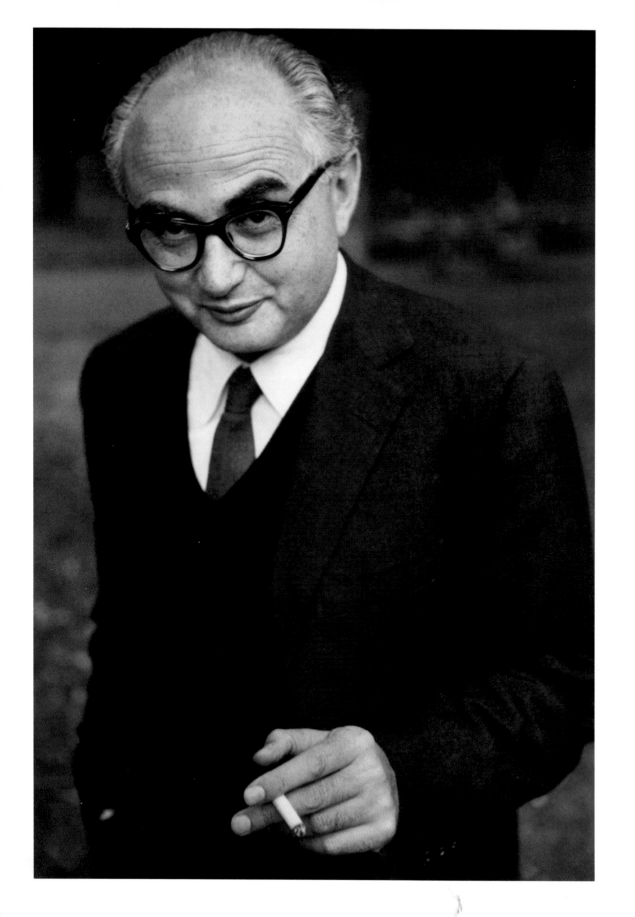

When the upheaval that characterized political and economic life in Europe in the 1930s dashed David Seymour's dreams of completing a science degree at the Sorbonne, he borrowed a camera from a family friend and began to take photographs that were so memorable they helped to redefine photojournalism. He brought to the genre the scientist's curiosity and the philosopher's understanding, and applied a powerful humanism to the making of his images.

Born Dawid Szymin on 20 November 1911 in Warsaw, Seymour grew up surrounded by art, music and literature. His father, Benjamin, was a respected publisher of Hebrew and Yiddish books whose bookstore was a meeting place for young writers from the *shtetl* (small towns). In fact, Benjamin was the first to publish Sholom Asch's *The Shtetl* as well as many other important books, including Yiddish translations of prominent writers such as Mark Twain, Guy de Maupassant and Heinrich Heine. Dawid, not surprisingly, was an avid reader who also excelled at languages (he would learn at least eight languages during his life).

The bombing of Warsaw in World War I forced the family to flee to the safety of Minsk, where Dawid's father had relatives. When the war came to the Ukraine, they continued their flight all the way to Odessa, where Benjamin had business ties to the Jewish community. With the end of the war, they made their way back to Poland, which had achieved independence in 1918, and Benjamin re-established himself in the publishing business,

David Seymour (Chim)
by Elliott Erwitt, 1956

leading the merger of several smaller publishers to form one of the largest Yiddish language presses in Warsaw. The family thrived in 1920s' Poland and Benjamin made plans to provide career opportunities in the publishing business for Dawid and his sister Eileen. Eileen, a talented writer three years older than her brother, was sent to study economics in Berlin while Dawid, having passed his baccalaureate in 1929, was sent to Leipzig's Staatliche Akademie für Graphische Künste und Buchgewerbe (the Akademie) to study printing technology.

Leipzig was a major printing and publishing centre with more than 200 printing firms and a comparable number of type foundries, binderies and related enterprises. When Dawid Szymin arrived there, he found a vibrant and sophisticated metropolis where Bach and Mendelssohn had once filled musical posts, and Leibniz and Wagner were celebrated native sons. He also found that Leipzig, like nearly every other German city, was increasingly affected by economic depression and political strife. Political rallies, like the 1930 Nazi rally near Leipzig, left several dead and many injured. The rise of Nazi Germany had begun.

Having graduated from the Akademie in 1931, Dawid returned home to find that economic and political conditions in Poland were also deteriorating. He decided to go to Paris and continue his education at the Sorbonne, where he studied chemistry and physics from 1932 to 1935. Concerned about draining family resources, he sought work in 1933 from David Rappaport, a family friend who lived in Paris and owned Rap, a 'pioneering picture agency', in the words of Seymour biographer Inge Bondi. It was from Rappaport that Dawid borrowed a camera with which to start taking serious photographs, and soon he was producing publishable images, his prints stamped with the name 'Chim' (pronounced *shim*), a shortened French version of his last name. While he may not have had any formal training in photography, Chim brought to his work a background in the graphic arts and a commitment to craftsmanship and scientific truth.

The world of photojournalism into which Chim had plunged was undergoing redefinition. Mass-appeal magazines were proliferating and being produced faster and cheaper and with more photographic illustrations than ever before. The picture story, a relatively new concept, was being developed by such innovative editors as Stephen Lorant at the *Münchner Illustrierte Presse* and Kurt Korff and Kurt Safranski at the *Berliner Illustrierte Zeitung* (*BIZ*). Lorant encouraged photographers to make images in series, while Korff and Safranski endorsed the 'third effect', the interaction between two pictures to produce an idea not found in either picture alone. Korff and Safranski believed that when photographs were intentionally placed together, the combination could symbolize 'something larger'. Many of the images that appeared in *BIZ* were made by such famous photographers as Felix Man and Umbo (Otto Umbehr), who worked for a Berlin picture agency called Dephot (an abbreviation of *Deutsches Photodienst*, or German Photo Service). Dephot was operated by Simon Guttmann who, according to historians Colin Osman and Sandra Phillips, would pre-plan a picture story as a 'unified, coherent presentation' before sending a photographer to take the pictures. The resulting tightly organized articles had precisely-made and edited images that relied less on text or captions.

Another way in which photojournalism was being redefined was through use of the Leica camera. With this revolutionary, miniature camera, innovative photographers were able to make the less formal, more spontaneous images that were becoming so popular in magazines. The Leica had been devised in 1913 by Dr Oskar Barnack, an engineer for E. Leitz Optische Werke in Wetzlar, Germany, but, with the interruption of World War I, it was not placed on the market until 1925. It used 35mm film and had a razor-sharp lens that gathered light so effectively it could be used readily in low-light situations. The small size of the Leica allowed photographers to be unobtrusive. Chim was among those who took to the Leica early and used it effectively.

Despite the economic depression, Paris in the 1930s was still a city rich in bohemian life. A famous meeting ground for that life was Le Dôme, the Montparnasse café whose booths were decorated by the artists who frequented those seats and occasionally paid for their meals with drawings and paintings. The café terrace was a place where one could sit over a drink and watch the world go by, while waiting for someone else to arrive and pay for the drink. It was also a place to meet and make friends, discuss art and politics, and occasionally catch sight of Pablo Picasso, Henry Miller or Man Ray. Chim, Robert Capa and Henri Cartier-Bresson were three unlikely friends who met in Paris and stopped occasionally at Le Dôme for conversation and a drink. Capa, whose real name was Endre Ernö Friedmann, was a Hungarian Jewish immigrant who had left his native Budapest to study at the Deutsche Hochschule für Politik in Berlin. He was a fast learner, but 'not an ardent student' (in the words of Capa biographer Richard Whelan). Forced to seek work when his family could no longer support him, he got a job working in the darkroom at Dephot, learning much from Guttmann as well as from Umbo and Man. Increasing Nazi attacks on Jews led Capa to Budapest for a short time before going to Paris in late summer 1933.

How Chim and Capa met is not known, perhaps at Le Dôme, where many émigrés gathered. They could not have been more different. Richard Whelan has described the handsome, chunky and swarthy Capa as gregarious and rambunctious, and Chim as shy and courtly, more like a rabbi or a chess player. Chim was an intellectual and a philosopher, while Capa was a very charming and intelligent man-about-town. They became inseparable friends; undoubtedly each had qualities that the other admired and wished to acquire. Capa appreciated his friend's moral judgment and eye for an image. As Whelan reported, Capa always said that Chim was the better photographer. Chim certainly enjoyed his friend's confident sociability, thoughtfulness and easy manner. Although they were both Jewish young men from Central Europe, who were forced by circumstances to seek their fortunes

away from home, their reasons for leaving home were quite different. Capa had left Hungary to study abroad in exchange for release from custody for leftist political agitation, and Seymour had realized that his opportunities would be severely limited if he stayed in Poland. Both had studied in Germany before landing in Paris, and they shared the socialist ideal of helping the working class. They were a duo that soon became a trio of friends when Chim introduced Capa to Cartier-Bresson.

Chim met Henri Cartier-Bresson on a tram riding down Boulevard Montparnasse in 1933. Cartier-Bresson said in a personal interview, 'He was carrying a camera, and I asked him: "What is that gadget?"' It was his means of opening a conversation with the studious-looking Chim. The lifelong friendship that rapidly developed between the two men was based not so much on cameras and photography as on their rich conversations about politics, aesthetics, family, food and women.

Cartier-Bresson was born in Normandy, but grew up in Paris. As a member of an upper-class family whose wealth was based on textile manufacturing, he had a privileged education that included studying at Cambridge University. As a teenager, he studied painting with artists such as Jacques-Émile Blanche (a friend of Marcel Proust and Gertrude Stein) and André Lhote, a prominent Cubist. Fascinated by the Surrealists, he frequently listened in rapt attention as André Breton and his colleagues discussed art and life at their favourite Left Bank cafés. Surrealist ideas continued to influence him when he began photography in 1930. His initial introduction to the medium led him to buy a Leica and travel to Germany, Poland and Hungary, places that brought the three friends, with their common interest in photography, together. Chim and Cartier-Bresson shared intellectual musings as well as admiration for the writers James Joyce and Romain Rolland, and composers such as Antonio Vivaldi, Johann Sebastian Bach and Frédéric Chopin. They also both appreciated Capa's high-spirited and spontaneous nature and his unhindered optimism.

Politics frequently dominated their conversations. The rise of Nazi Germany left little room for moderation in political thought. It convinced the French parties of the Left (the Radicals, Socialists and Communists) to form the Front Populaire in 1935 in the hope that they might get enough seats in the 1936 elections to have a majority in the Chamber of Deputies. The parties of the Right (Conservatives, Ultra-Conservatives, Royalists and Fascists) feared the Left because of the increasing power and influence of Soviet Russia. Deterioration of economic conditions in France did indeed swing the elections in favour of a Front Populaire majority, and the leader of the Socialist Party, Léon Blum, became prime minister.

Chim had already photographed Blum (no. 5) on a variety of occasions for *Regards*, a magazine strongly sympathetic to the Front Populaire. As early as 1933 he had begun assignments for the magazine, and was appointed staff photographer when it became a weekly a year later. *Regards* gave birth to humanist photography in France, and Chim deserves significant credit for the magazine's photographic accomplishments. The faces in Chim's images reveal a yearning for 'a new deal' not unlike the one Franklin Roosevelt was crafting in the United States. French workers gained from their Front Populaire government a forty-hour working week, paid vacations and collective bargaining – benefits they had long sought. The story of the Front Populaire campaign in the crucial 1936 elections was equalled in importance only by the outbreak that year of the Spanish Civil War. Since Chim had to divide his time between France and Spain, he recommended to his editors that Capa assist with the stories – a job that Capa readily accepted.

Twenty years of civil strife in Spain had finally erupted into armed conflict, but the immediate cause was opposition by right-wing groups to the narrow electoral victory of the leftist Frente Popular. General Francisco Franco led his troops against the new government to save Spain from 'the Red Revolution', according to historian Norman Davies, while the government sought to preserve democracy. Many issues contributed to the

conflict, but land reform was a very important one. Most of the productive land in Spain was owned by the elite, while peasants worked for starvation wages. The Roman Catholic Church, also a major landowner, resisted reform, and, along with the elite, sided with Franco. Overlaying the many national issues were the economic depression and the international Right–Left conflict in Europe. The Spanish Right had strong support from Nazi Germany, Fascist Italy, and right-wing Portugal, while the Left had some support from Soviet Russia and an international brigade of sympathizers who joined the fight to save the elected government.

Chim was one of the first on the scene and photographed government supporters fighting the rebels who were both better trained and armed. He quickly relinquished battlefield coverage to Capa, who arrived shortly afterwards with his girlfriend, Gerda Taro, herself a photographer and German expatriate. A man of peace and compassion, Chim preferred to focus his efforts on the civilians away from the battlefield. One of his most revealing images depicts a woman nursing a baby while attending a land reform meeting (no. 8). She is looking up, squinting with her brow furrowed against strong side lighting. Her plain face expresses mixed emotions: hope, concern and wariness. Chim found her the perfect icon for the struggle to preserve freedom and democracy in Spain.

Ultimately, government supporters lost the war, and many became refugees in France. About 150,000 obtained passage to Mexico and South America, including the 1,000 passengers who boarded the S.S. *Sinaia*. They were accompanied by Chim and the writer George Soria, who were on assignment for *Paris Match* to report on the voyage. A grand welcome was given to the refugees by the Mexicans, and Chim was invited by President Lázaro Cárdenas to photograph Mexican life under his government. Cárdenas had taken office in 1934 with promises of reform and honest government. He managed to improve workers' wages and distributed more land from the haciendas to peasant cooperatives than any previous president had done. Foreign-owned oil properties were

expropriated to bring more profits into the Mexican treasury. Chim focused his camera on workers, children and festivals, but his most dramatic images were of oil refineries. In these images he emphasized geometric relationships, angularity and monumentality (nos 12, 13). Far from neutral, they celebrate the refineries and extol the new socialist Mexico.

Chim left Mexico in late summer 1939, and arrived in New York just after World War II had begun. He evidently had no desire to be a war correspondent. In New York, he received one assignment from *Life* to cover 'Polish Week', but his best opportunity lay in opening a photo-finishing business. Named Leco, it was located on 42nd Street. Like his partner Leo Cohn, formerly a Berlin photographer, Chim was unable to get a work permit, but he nonetheless could be an employer, with young assistants whom he trained to perform the work. English became his seventh language as he spent the early war years applying his considerable administrative skills to organizing the business of making prints precisely the way photojournalists, such as Capa and Cartier-Bresson, wanted them. His background in chemistry and physics proved advantageous to achieving fine grain in film developing and superior print control. That the location of the business was near the editorial offices of magazines such as *Life* was not coincidental. Potential business clients were nearby, and he could learn from them the latest developments in Europe. Perhaps driven by anxiety over the fate of his parents, still living in occupied Poland, he attempted to volunteer his services to the US government before being drafted into the army in 1942. While in military intelligence training at Camp Ritchie, Maryland, he became a naturalized US citizen at the nearby courthouse in Hagerstown, and took a new name, David Robert Seymour, as he was fearful of reprisals by the Nazis against his family. His parents later died in a Jewish ghetto in Poland.

Seymour's service in the US Army (October 1942 to December 1945) was distinguished by several promotions and various

decorations for his contributions to victory. Working as a photo-interpreter in England, his profound understanding of photography and detailed knowledge of Europe undoubtedly provided rare insight. Frequently he briefed high-ranking officers about findings gleaned from aerial photographs. He landed in France shortly after D-Day, and celebrated the liberation of Paris with Capa and Cartier-Bresson amongst others at Brunhoff's café in the city. Although victory in Europe was still months away, the end of the war was in sight.

Following World War II, Capa lost no time in acting upon an idea that he had been thinking about for years. He wanted to set up a new kind of picture agency, an international photographic cooperative with editorial independence, where photographers – not editors – were in charge. Naturally Seymour and Cartier-Bresson became his partners in the new endeavour, along with Englishman George Rodger. International in background as well as outlook, they divided coverage of the world so that Seymour would work primarily in Europe, Cartier-Bresson in Asia, Rodger in Africa and the Middle East, and Capa at large. Magazine circulation was soaring in the 1940s and 1950s to ever better-educated audiences eager for information. As magazine stories became increasingly complex, editors believed that pictures would make the stories more comprehensible. They also found that colour images added emotional depth. While Seymour was still with Leco, and prior to resuming his photography career, he taught himself to photograph in colour, concentrating on the 35mm and 120mm transparencies sought by editors. However, rather than taking orders from editors, whether for colour or black-and-white images, Capa believed that photographers free of traditional strictures would be well positioned to provide a high quality, steady flow of photographs to the magazines.

Magnum Photos was launched in 1947, the same year that Seymour resumed his career with an assignment from *This Week* magazine to photograph in Germany. Entitled 'We Went Back',

it showed not only the devastation that the war had brought, but also the beginnings of new hope as people coped with the difficulties of postwar life symbolized by a lively baby, born illegitimately, lying in a carriage parked among the ruins of Essen (no. 15). A couple tends a garden growing in front of the scorched and pockmarked Reichstag building in Berlin (no. 16). A man missing a leg (an apt symbol for Germany as a whole) participates in an election rally in Munich (no. 29). Seymour, who had graphically demonstrated his ability to summarize history with his Spanish Civil War photographs, revealed a more philosophical and symbolic approach with his German images.

Nowhere is his new approach better seen, however, than in his photographs of children. Children had been a favourite subject of Seymour's since he first started photography, and, whenever possible, he added to this growing body of work. In 1948, he eagerly accepted an assignment from the newly established United Nations International Children's Emergency Fund (UNICEF) to travel to Poland, Hungary, Austria, Italy and Greece and show the deplorable condition of Europe's needy children and the work being done by UNICEF. No other images revealed so completely the depths of Seymour's humanitarian sympathies. One sees children amusingly making faces for the camera (no. 18), plaintively holding up their soup cups, and joyously playing despite war-incurred disabilities (no. 23). Even more moving are his photographs of emotionally disturbed children that reveal the horrifying psychological wounds that lingered long after the war had ended (no. 21).

Chim instinctively understood and sympathized with children, and they in turn responded to and trusted him. He would often get down to the eye level of the child (nos 24, 26) or group of children, allowing viewers to gain something of their perspective on the world. His facility with languages must have helped in establishing a rapport with many of his subjects. Touching moments abound, such as the image of one little girl lovingly

embracing her broken doll (no. 24) or another with her first pair of shoes (no. 17). Seymour excelled at revealing the emotions of others because he had loved, been loved, and had suffered wartime losses. He saw and felt, and then translated his own powerful emotions into photographs. He brought immense compassion to his work, combating the inhumanity that produced war and the suffering of these children. A selection of his photographs was published as *The Children of Europe* by the United Nations Educational, Scientific and Cultural Organization (UNESCO) in 1949 with this concluding statement, written as though it had been spoken by one of the children: 'Share your world with us ... Do not abandon us a second time and make us lose forever our faith in the ideals for which you fought.' Seymour's hopes for these children, revealed in his photographs, would not be realized for some time as the 'Iron Curtain' foretold by Britain's Winston Churchill descended upon Eastern Europe. Perhaps to avoid political stories, Seymour did not visit Eastern Europe again. His lifeline, wherever his pursuit of images took him, was always Magnum, which was growing and evolving as an organization. In 1953, John Morris, a picture editor with experience at *Life* and *Ladies Home Journal*, was hired as International Executive Editor of Magnum with authority over both the New York and Paris offices. Morris and Seymour became in time the best of friends.

Perhaps as a release from the stresses of war, public interest focused on celebrities, especially film stars, and entertainment became a popular subject. The humanity that Seymour brought to photographing children he also applied to photographing personalities such as Ingrid Bergman, Kirk Douglas, Sophia Loren, Gina Lollobrigida and many others. Just as he inspired trust from children, so he did from the film stars he photographed. Gently he insinuated himself into their lives by talking about subjects of mutual interest, all the while photographing them, looking for the human being rather than the film idol. Sometimes the poses were determined by the subject, as when he first photographed Sophia Loren. The session was conducted on the balcony of her

home in Naples, Italy, with Loren posing as if doing pre-war pin-ups, Seymour noted. Then she relaxed for a moment seated on a small table, and he made the most revealing image of the session – at once sensuous, elegant, inviting and vulnerable (no. 48). The images of Sophia Loren undoubtedly contributed to her career, but probably no celebrity benefited from Seymour's photographs as much as the young film star Gina Lollobrigida. The photographs of her appeared in *Life*, one of the most widely circulated magazines at the time. She was working on her US film debut in John Huston's *Beat the Devil*, and Seymour photographed her in rich black and white as well as sumptuous colour. The resulting images, made on the set of the film as well as at her home, are full of sensuality as well as candour.

For Seymour and Magnum, 1954 was a very difficult year. He became president of Magnum upon the death of Capa who was killed by a land mine while covering the war in Indochina. The loss hit Seymour especially hard because Capa had been his close friend and confidant for more than twenty years. Photography and the whole world were poorer for the loss. Much was required of Seymour to keep Magnum going and to pursue his own photography, particularly in Greece and Israel. Greece had captured his fascination, but Israel had captured his heart. He saw in Israel not just a new nation, but one being born in adversity by the gathering of Jewish people from disparate places for a common goal, the creation of a Jewish homeland in the aftermath of the Holocaust.

In 1956, as Seymour vacationed in Greece, the Middle East erupted with the Suez crisis. Raids on Israel by Egyptian commandos had increased following the nationalization of the Suez Canal by Egyptian leader Gamel Abdel Nasser, and matters promised to get worse as armaments poured into Egypt from the Soviet Union. Israel mobilized and invaded the Sinai Peninsula to remove the havens where the raids originated. While the international press corps was trying to obtain passage from Athens directly to Port Said, Egypt, Seymour figured it might be easier to get there

from Cyprus. He intended to cross over to Israel subsequent to photographing in Egypt. After obtaining press accreditation documents, he boarded a flight to Port Said with other journalists including Ben Bradlee (*Newsweek*) and Frank White (*Time-Life*). Sixteen years had elapsed since Seymour had been in a war zone as a photographer, but he was invigorated rather than threatened by the war. Four days after an armistice was signed, he rode with Jean Roy (*Paris Match*) to cover an exchange of wounded prisoners of war. Both were gunned down as Roy sped past the Egyptian lines to the exchange location. A brilliant life ended in an instant on 10 November 1956 as the bullet-riddled jeep careened off the road and into the Suez Canal.

In addition to his photographs, Seymour's legacy includes Magnum itself and his mentoring of the next generation of great Magnum photographers including Burt Glinn, who photographed *Havana: The Revolutionary Moment* and *A Portrait of All the Russias*. Cartier-Bresson gave the greatest tribute to his friend when he said, 'Chim picked up his camera the way a doctor takes his stethoscope out of his bag, applying his diagnosis to the condition of the heart. His own was vulnerable.' This statement captures David Seymour as scientist and philosopher, but most of all as humanist. And it was an immense humanism that he brought to international photojournalism through his independently assembled picture stories. He felt deeply the wounds to the human spirit that conflict brings, and sought through his photographs to show that, despite the atrocities of war, there is still hope for humanity.

1933 Meat Cutter, Les Halles, Paris, France.

Seymour's early photographs of Paris captured the everyday face of the city as well as its more famous sights. In November 1933 he photographed Les Halles, the old central market of Paris, a structure made up of ten gigantic halls constructed between 1854 and 1866. It housed wholesale butchers, fishmongers and food merchants of all sorts, but at night it could be a dangerous place. With two friends as bodyguards, Seymour roamed the halls until 3 a.m., and reported: 'In the meat packing section we had a triumphal reception with wine. They let us into the huge freezer-chambers.' The legendary photographer Brassaï was already famous for his night photographs of Paris.

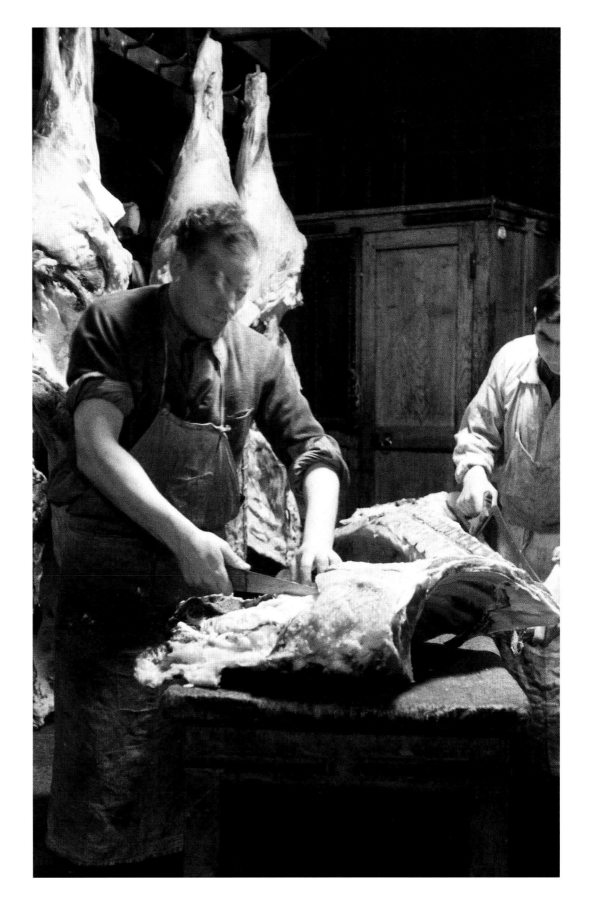

c.1933 Children, Paris, France.

Many of Seymour's early photographs of Paris seem to have been made without a specific assignment. Children were one of his earliest inspirations. It is not known exactly how much photographic experience he had before his arrival in Paris – and there is no indication that he had any background in photojournalism – but Seymour had a natural ability to photograph children.

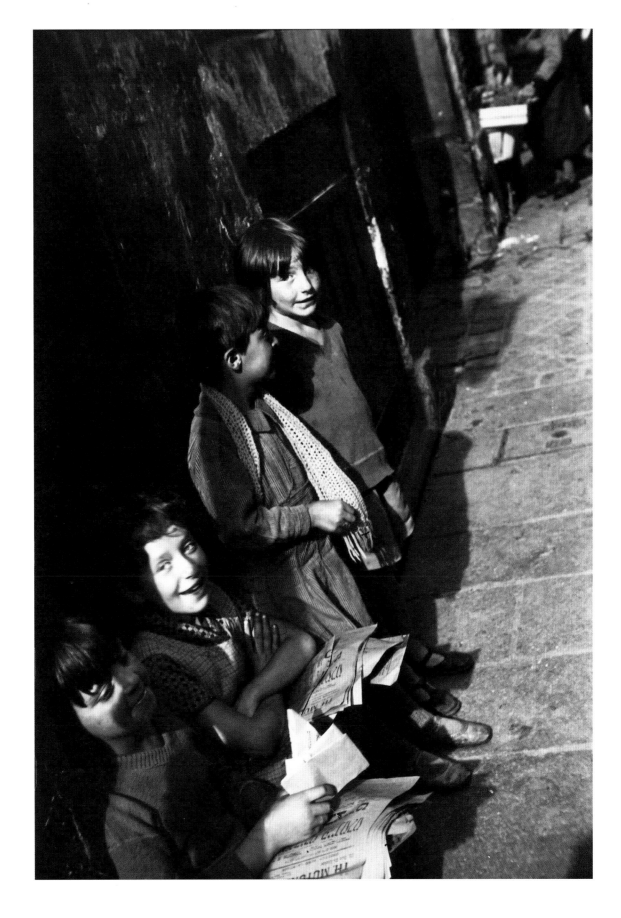

1933–4 Eiffel Tower, Paris, France.

In these early images, Seymour seems to have been trying out different styles of photography. This image of the Eiffel Tower demonstrates his use of 'pictorial style', an approach characterized by careful composition in the manner of nineteenth-century academic painting and a style which, by the 1930s, was already well developed in the work of Clarence White, Ralph Steiner and A. Aubrey Bodine.

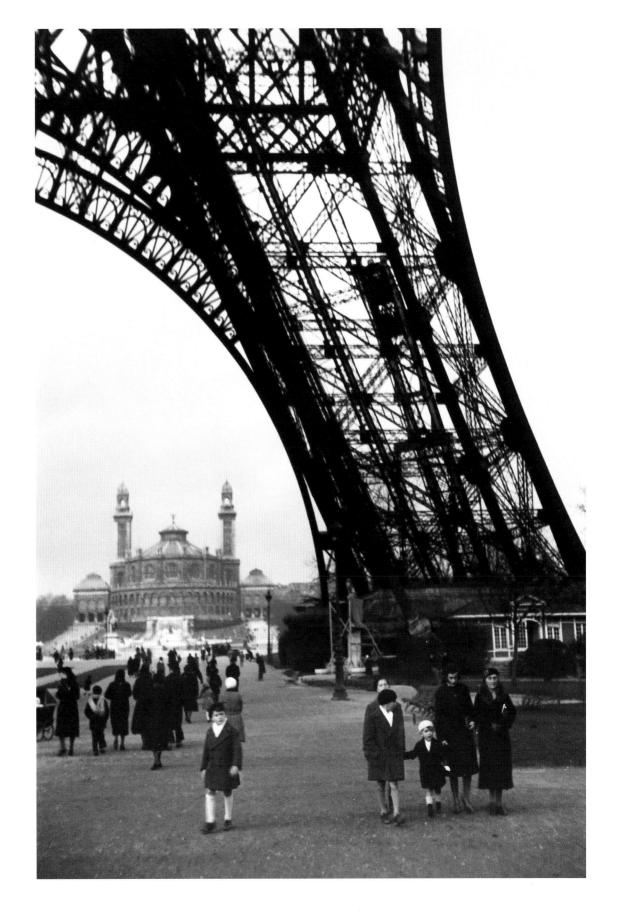

1934 Man on Bridge, Paris, France.

Seymour was familiar with innovations that were occurring in the visual arts in the 1920s and 1930s. While he was a student in Leipzig at the Staatliche Akademie für Graphische Künste und Buchgewerbe between 1929 and 1931, Russian Constructivism gained widespread recognition. Characteristic of Constructivist photography (for example, the work of Rodchenko) was an emphasis on geometric relationships, structural qualities and foreshortened perspective, all of which can be seen in this image.

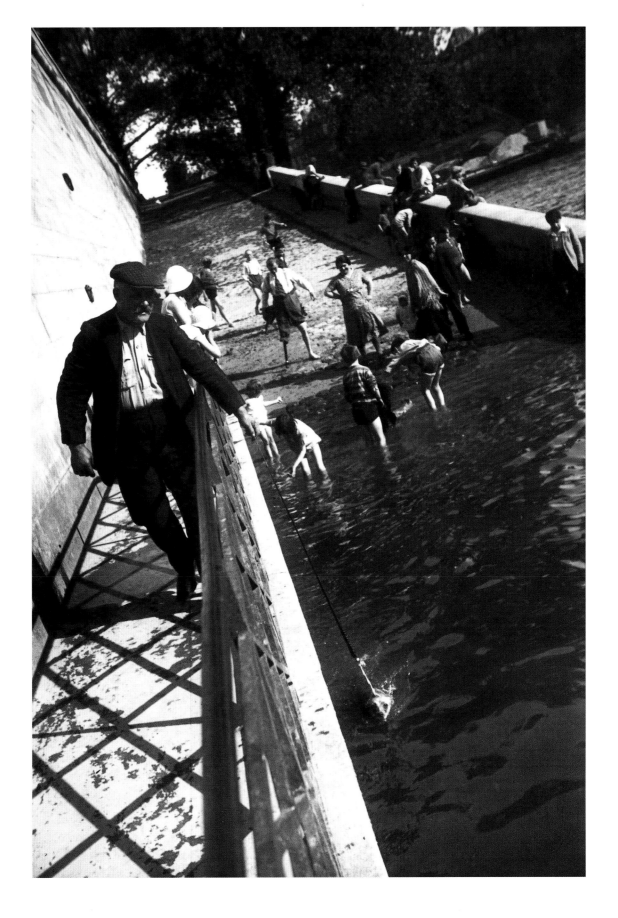

1935

Léon Blum, Maurice Thorez and André Marty at
a Front Populaire March, Paris.

During the mid-1930s Seymour was working in Paris for *Regards* magazine
at a time of mass demonstrations, a worsening economy, unemployment and
the threat of war with Germany. An intellectual with a social conscience,
Seymour made images that reveal not only his sympathy with his subjects
but also his editorial judgement. Grasping the political implications, he
photographed Léon Blum, then leader of the Front Populaire, against the
Mur des Fédérés, the wall at Père Lachaise Cemetery where the last Paris
Communards were executed in 1871. It demonstrates Seymour's skill of
telling a story with a single photograph and his ability to take candid
pictures with a Leica camera.

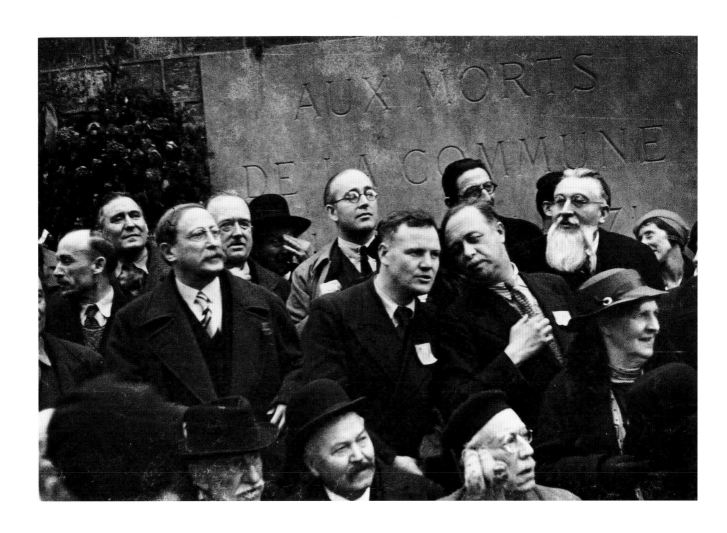

06 1936 Group of Miners at a Front Populaire Rally, Montrouge, near Paris, France.

The Front Populaire victory rally, held on 12 June 1936 at the Buffalo bicycle track at Montrouge, was attended by thousands. Dressed to identify themselves as miners, the men in this image celebrate winning a majority in the national legislature. The image is a fascinating study of the faces of the miners, who look at the viewer with pathos, fully aware that they are being photographed and of their role at the rally. Seymour knew well how photography could humanize subjects and connect them to the viewer.

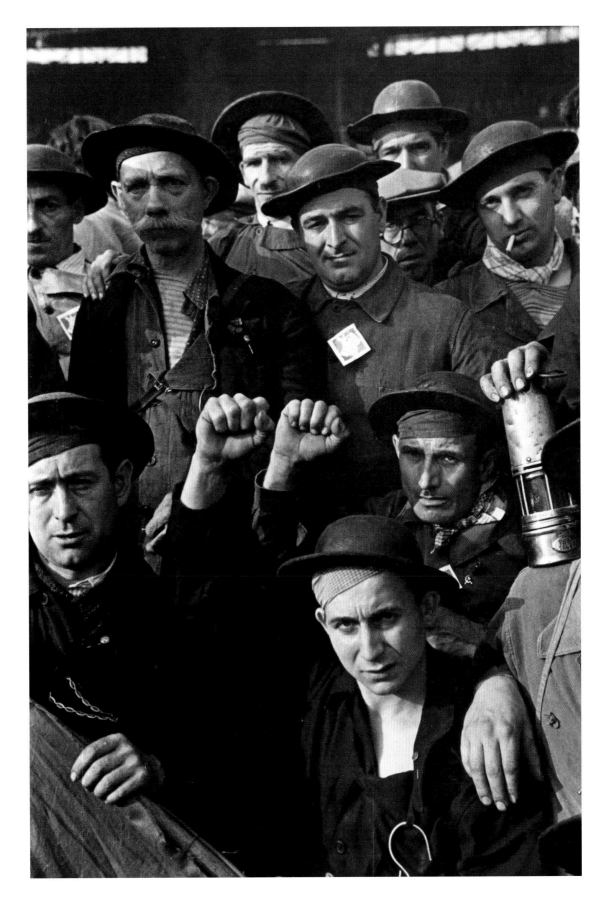

1936 | Striking Workers Occupy the Renault Factory outside Paris, France.

In 1936 a national strike for the 40-hour week took place in France. A strong graphic quality and flair for composition characterizes many of Seymour's early photographs of Paris: here, he contrasts the workers with the rigid smokestack – labour versus capital. Seymour was politically sophisticated, as is evident from his insightful images taken for *Regards*.

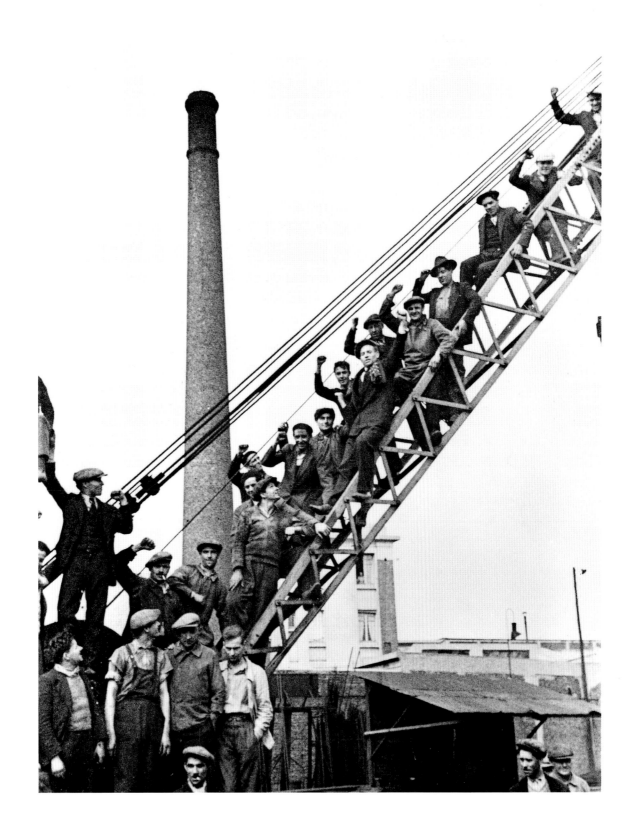

1936 Woman at Land Reform Meeting, Estremadura, Spain.

This is one of Seymour's most recognizable images and an icon of the Spanish Civil War. He had been sent by *Regards* to report on the volatile political situation in Spain. Land distribution had become a pressing issue, especially in the impoverished region of Estremadura, where thousands of peasants had occupied land held by absentee landowners. This image demonstrates Seymour's involvement with and concern for people and their plight during times of conflict. It also reveals that Seymour was more concerned for the underlying causes and effects of the conflict than the frontline action. The woman is listening to a speech about land reform while feeding her baby. Attempts by the Spanish government to improve the lives of ordinary people are personalized by this close-up view of one woman in a crowd.

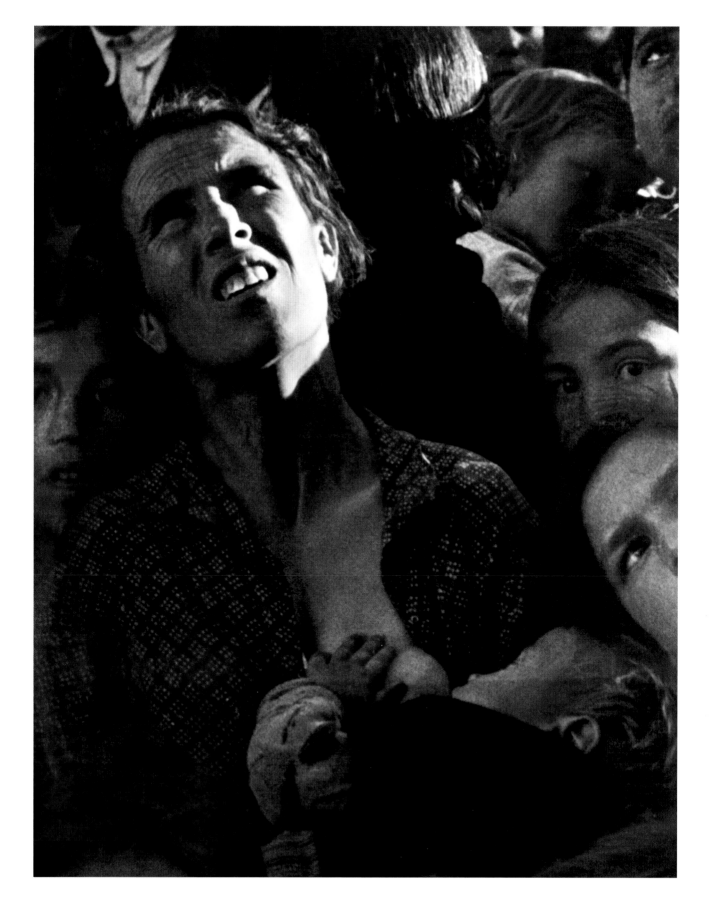

1936	Republican Pilots with Soviet Fighter Plane, near Madrid, Spain.

During the early months of the Spanish Civil War, the government received military assistance from the Soviet Union, which supplied the Polikarpov fighter plane shown in this photograph. The intention behind the image was not only to show off the newly delivered airplanes, but also to demonstrate the confidence of the pilots. Wanting to focus the story on the pilots and the plane, Seymour cropped the image tightly and carefully omitted any explanation about who furnished the somewhat surreal table setting and the meal.

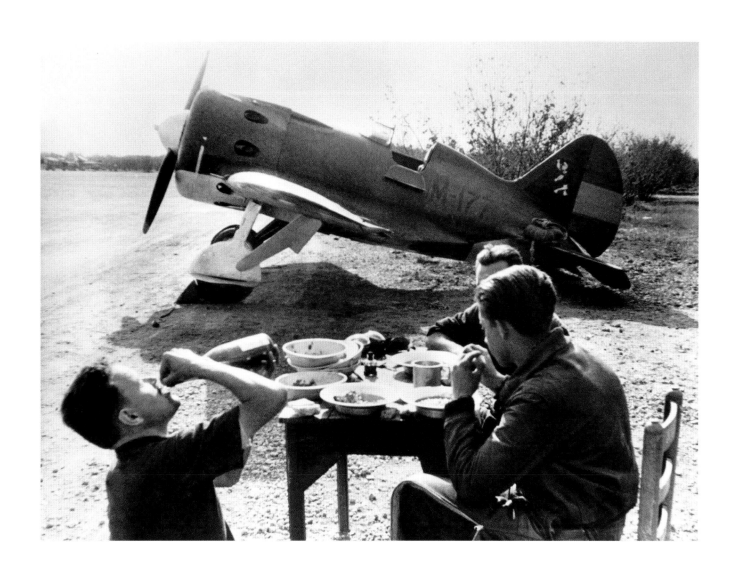

1937 Pablo Picasso in front of *Guernica*, Paris, France.

Seymour photographed Picasso in front of his famous painting *Guernica* soon after it had been unveiled at the 1937 World's Fair in Paris. Picasso completed the painting in time for it to be installed in the Spanish Pavilion, just six weeks after the Basque village was bombed by the Condor Legion of the German airforce under the direction of Spanish rebel General Franco. The painting became an international symbol of the cause of democracy in Spain; this photograph portrays Picasso as Spanish Republican patriot. Seymour depicted Picasso as part of the painting and placed him, as Cartier-Bresson had done with some of his portrait subjects, at the bottom of the frame. Having two centres of attention invites the viewer to compare Picasso to the other elements of the image.

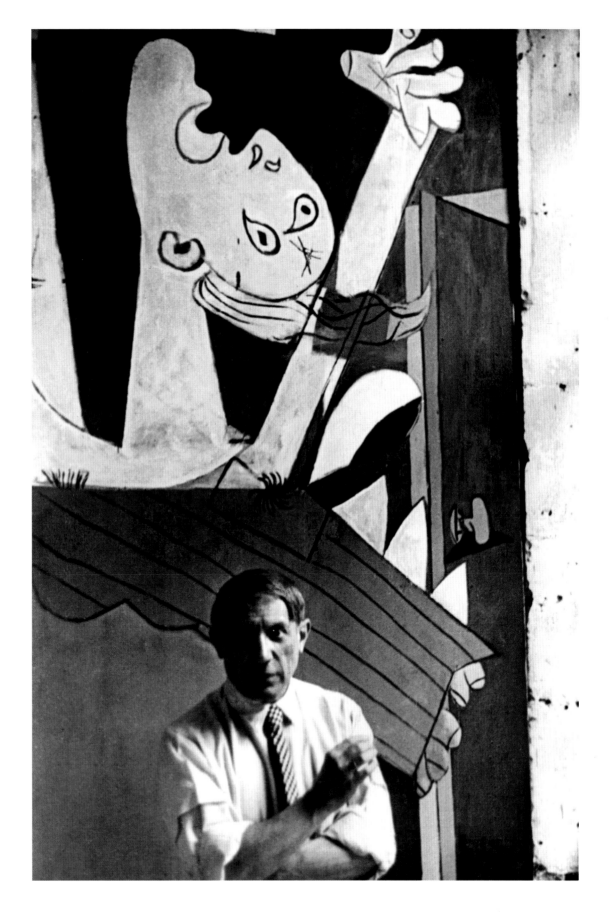

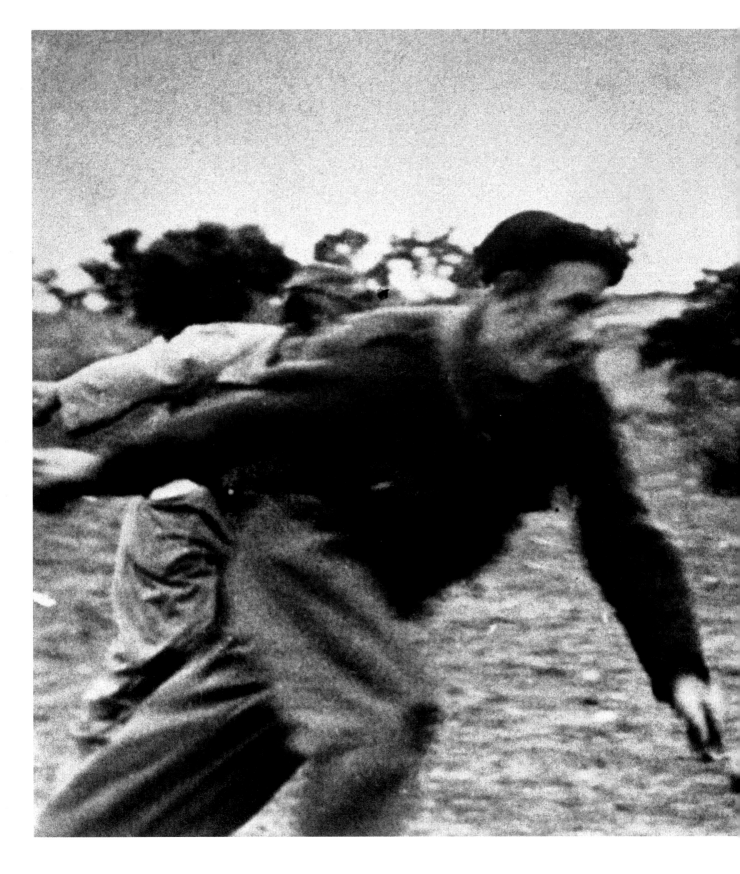

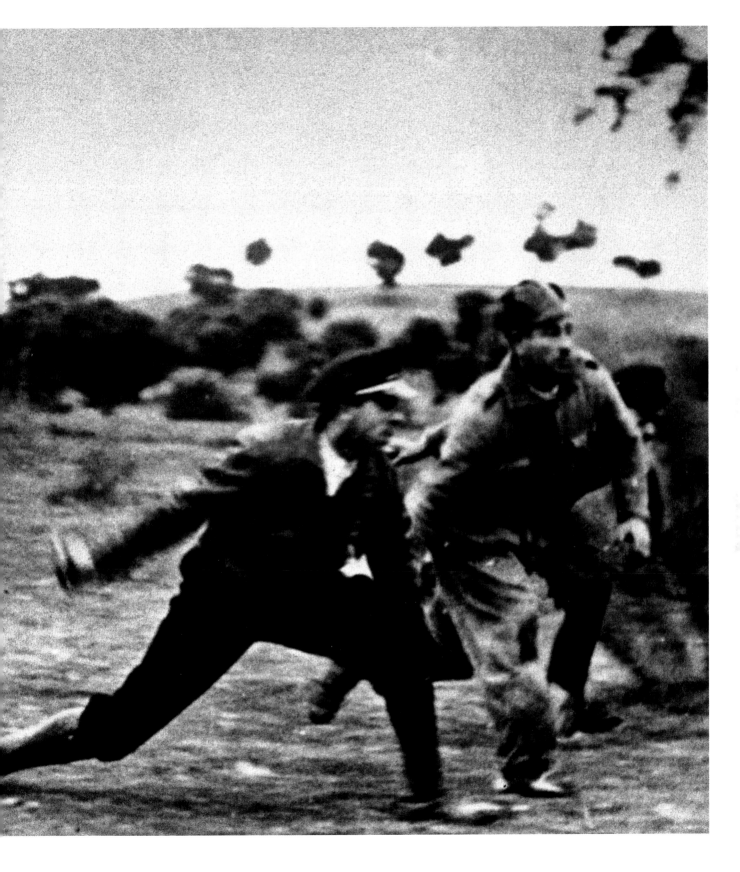

11 *previous page*	1938	Battle of Ebro, Spain.

This image represents one of the few battle photographs that Seymour took. A man of peace, he had no taste for war but was quite able to make effective pictures under battlefield conditions. Before this time, close-up battle images were relatively rare, and images where the photographer was simultaneously running with and photographing the combatants were even rarer. Seymour and Capa were among the first to photograph war this intimately. Using the 35mm camera certainly assisted in taking such candid photographs, but more important was Seymour's sympathy for his subjects and his courage under fire. The Battle of Ebro, during which Spanish government troops extended their control across the Ebro river from Barcelona, took place from 25 July to 3 August. Fiercely fought, as this image of a counter attack by Republican militiamen shows, the success was only a momentary glimmer of hope for the doomed government.

12	1939	Oil Refinery, Mexico.

In 1939, Seymour accompanied the exile of Spanish refugees to Mexico, where he was invited by President Lázaro Cárdenas to photograph changes under his Socialist government. Like sentries guarding the delicate Mexican economy, these high-pressure sediment tanks at a newly expropriated oil refinery seem to represent the rising power of the new Mexico in Seymour's anthropomorphic interpretation.

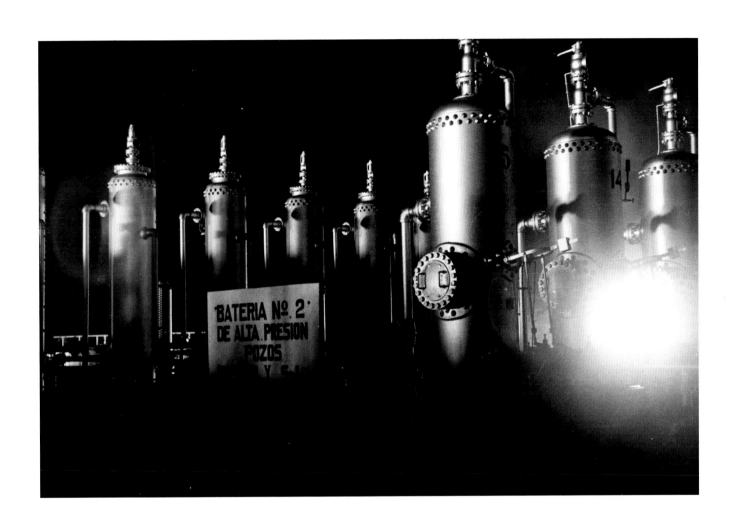

13 1939 | Oil Refinery, Mexico.

The carefully composed geometrical relationships formed by the buildings, the smokestacks and the fence suggest influences from Constructivism and Suprematism, artistic movements that would have been familiar to Seymour. He may have included the fence to represent the exclusion of foreign oil companies from Mexico the previous year.

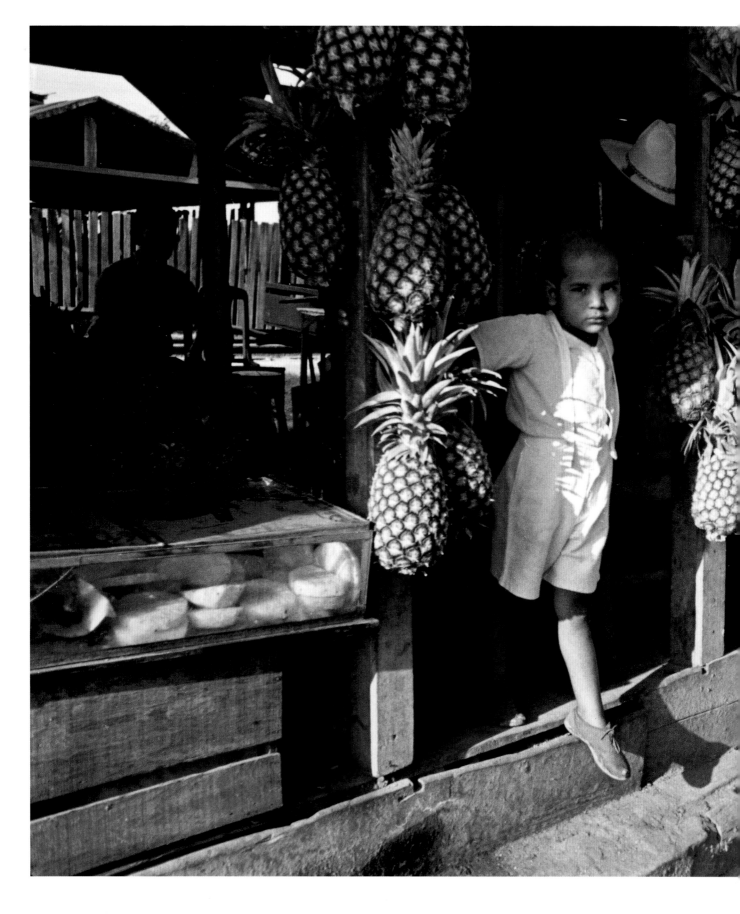

| 14 *previous page* | 1939 | Boy in Doorway, Mexico. |

Seymour was an explorer with the camera, who saw drama in the everyday lives of ordinary people. He was fascinated by children and found them to be willing ambassadors of their cultures, as in this image where the boy poses in a doorway adorned with pineapples. Away from Spain and the civil war, Seymour was able to experiment with strong contrasts of light and shade, and composition. Side lighting here adds texture, lending an extra dimension to the scene.

| 15 | 1947 | Baby among the Ruins, Essen, Germany. |

After military service in the US Army during World War II, Seymour returned to photography with an assignment in Europe for *This Week* magazine, entitled 'We Went Back'. His perennial optimism is represented by this photograph of an illegitimate newborn baby lying in a carriage among the ruins of postwar Germany. He saw that from those ruins would come a new generation that did not harbour the old hatreds that had brought about war.

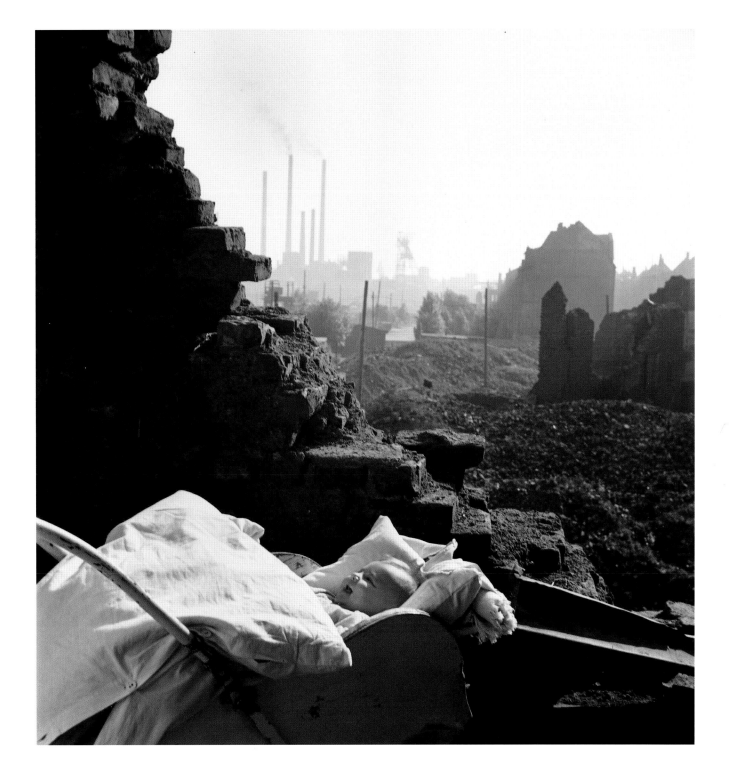

1947 Gardening amid Ruins in Front of the Reichstag, Berlin, Germany.

Ever the philosopher, Seymour saw postwar European life in the same terms as Voltaire more than 170 years earlier, who wrote 'We must cultivate our garden'. The ruin brought upon Germany by the Nazis loomed large over the German people who had to make gardens wherever possible to combat food shortages. Others grew vegetables in buckets, thus spawning what was known as a 'bucket economy'.

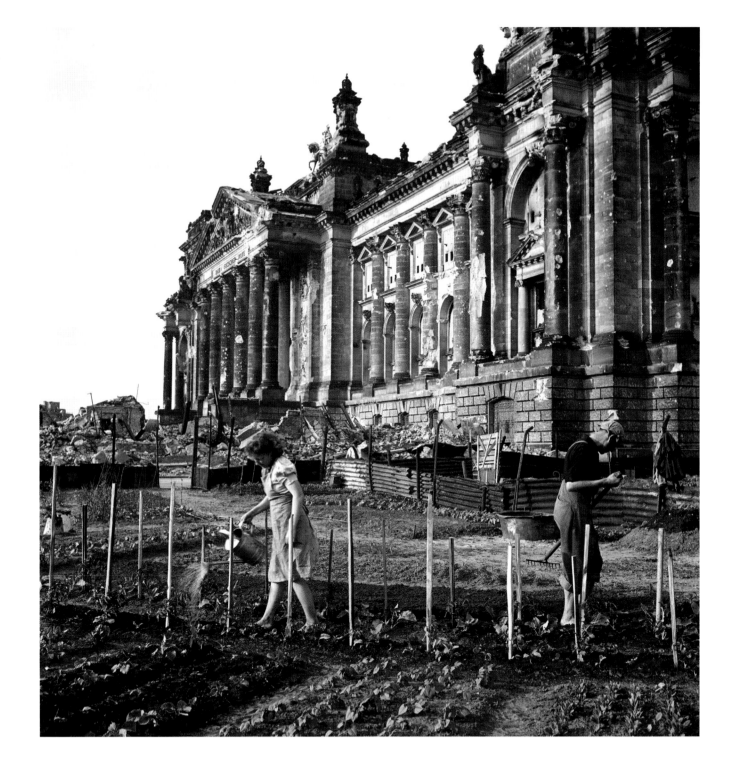

1948 Four-year-old Elefteria, Oxia, Greece.

Commissioned by UNICEF to photograph the children of postwar Europe, Seymour travelled extensively through Poland, Hungary, Germany, Czecho-slovakia, Greece and Italy during 1948. Poverty was acute in Greece; civil war had erupted following World War II and continued intermittently until 1949. Seymour travelled by mule on the UNICEF aid mission to the remote village of Oxia, bringing with him a pair of shoes for the only child not to be evacuated. This image of four-year-old Elefteria is one of Seymour's most touching photographs. He noted: 'For a long time ... Elefteria just stared at the new shoes. Finally, her grandmother was allowed to put them on her feet. Then the ice was broken. Elefteria ran through her village, laughing with delight. Her happiness was absolutely perfect.'

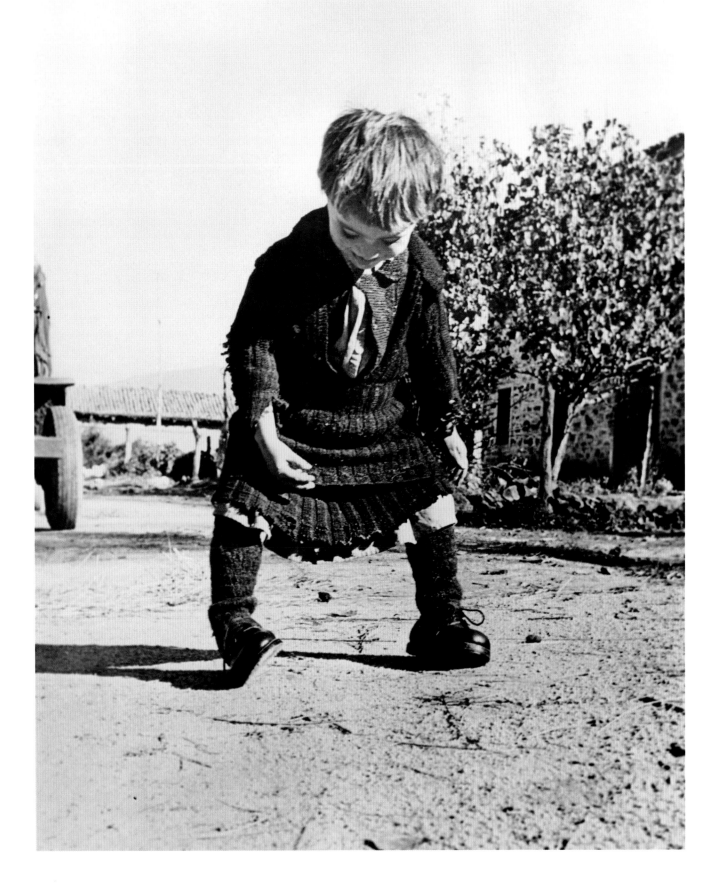

1948 Child in a Displaced Persons Camp, Vienna, Austria.

This child was from the 'Sudetenland', a territory ceded to Hitler in 1938 in a failed attempt to prevent his invasion of Czechoslovakia. After the war, a displaced persons camp was set up in a former Nazi military barracks in Vienna and supplied with food by UNICEF. Seymour, who could speak at least seven languages fluently, was able to communicate readily with these displaced and needy children, to whom he was like a playful uncle. Consequently, these are some of his most extraordinary images.

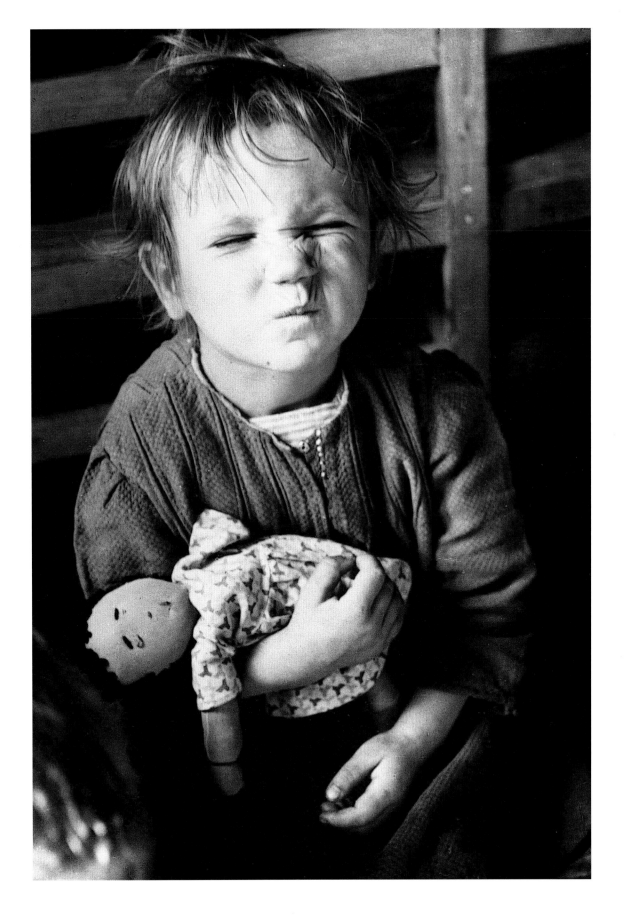

1948 A Child with Spinal Tuberculosis,
Bellevue Hospital for Children, Vienna, Austria.

Seymour was able to coax a broad smile from this little girl, who was so
severely disabled with tuberculosis that she had to wear a stiff body jacket
to hold her upper body erect. (He noted that while tuberculosis was always
pervasive in Vienna, there was a fifty per cent increase following the war,
despite a vigorous campaign against the disease.) Seymour arranged the
image so that the girl is highlighted while shown in the company of other
similarly afflicted children. With a great talent for making his images
appear to be without artifice, he carefully placed the child so that all lines
of composition focus on her. The image reveals Seymour's sophistication
in his use of such pictorial strategies.

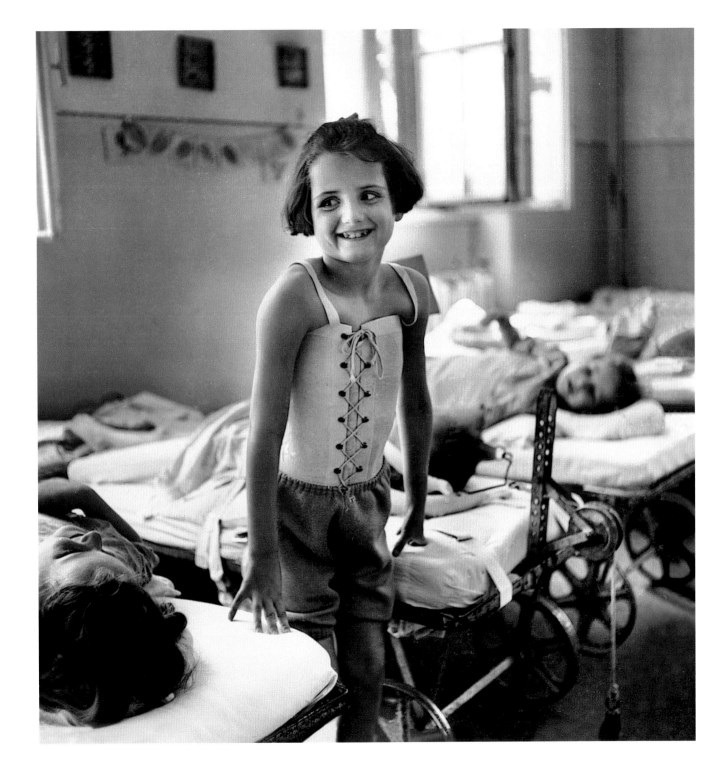

1948 Young Girl in a Sanatorium for Jewish Children, Otwock, Poland.

Otwock, a resort town not far from Warsaw, had more than a passing signifi-
cance for Seymour. Not only was it the town where his family formerly had
a summer home, later used by the Polish government as an orphanage, but
it was also where his parents had died in 1942 in a ghetto created by the
Germans. One can only guess at the mix of emotions that Seymour must
have felt when he returned to Otwock for the first time after the war and
photographed this young girl suffering from tuberculosis.

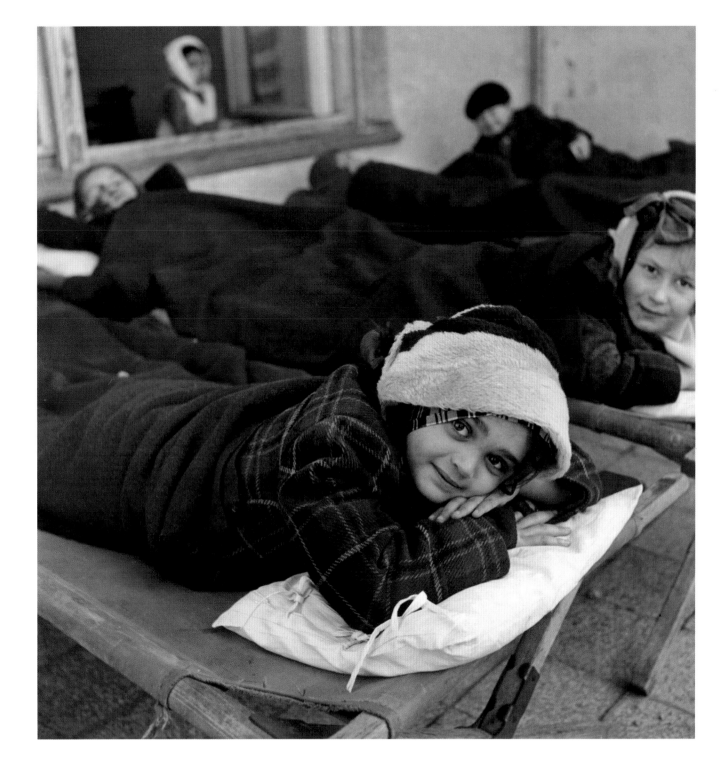

1948 Tereska, a Child in a Residence for Disturbed Children, Poland.

Tereska grew up in a German concentration camp amid the unspeakable horrors that occurred there during World War II. When Seymour photographed her, she was living in a home for disturbed children. Asked to depict 'home' on the blackboard, she drew only confusing lines. She looks up from her drawing, but seems less aware of Seymour than the demons that still afflict her.

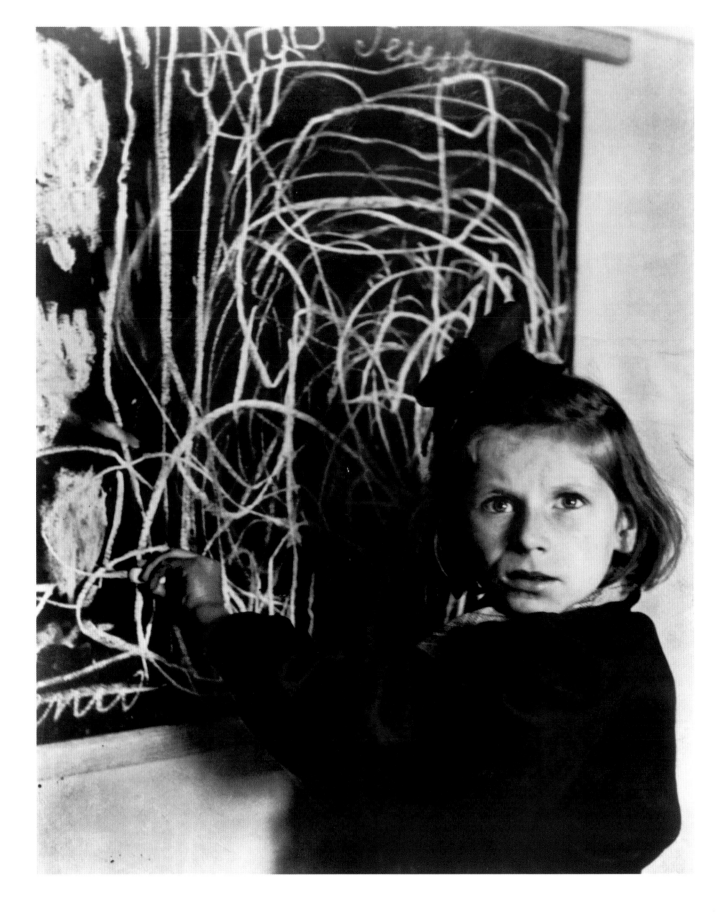

1948 Young Neapolitans in a Reformatory, Naples, Italy.

These boys had been remanded by the Juvenile Court to a reformatory in the Albergo dei Poveri where, subjected to the most rigid discipline, they attended school and learned trades in the shop attached to the reformatory. Not surprisingly, they greeted Seymour with a mixture of curiosity and suspicion. Seymour met their gaze with a fascination for each individual as well as for the group. By filling the frame completely he achieved the kind of intimacy that characterized his interest in all those he photographed.

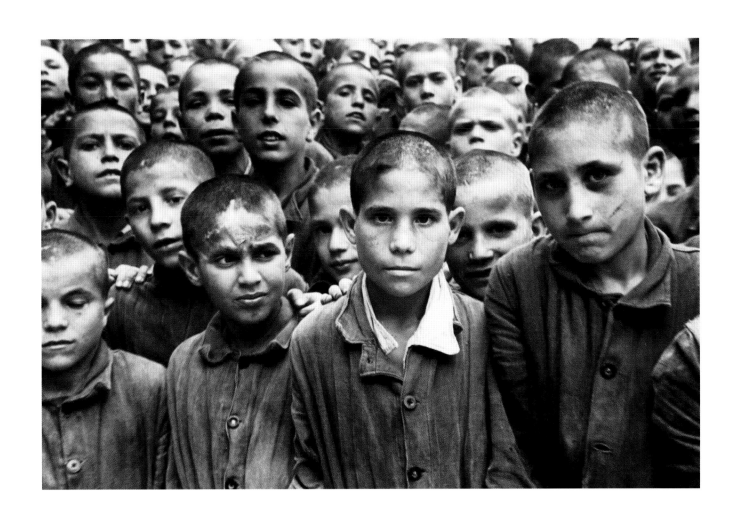

23 1948 Children Maimed by War, Villa Savoia, Rome, Italy.

These children had been maimed during the war, either directly or through accidents, such as playing with leftover ammunition. Yet Seymour's use of back lighting graphically emphasizes the animation of these children, as well as their missing limbs; he portrays them not as hopeless cripples but as energetic young boys playing a ball game.

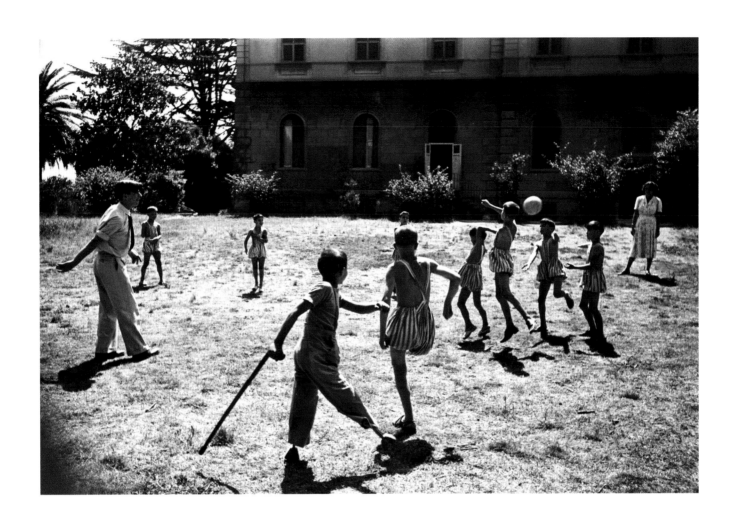

24 1948 Child Playing with a Broken Doll, Naples, Italy.

On occasion, Seymour found subjects that produced especially touching photographs, such this one of a child playing with a broken doll. Although the doll is hardly recognizable, it is a most dear object to the little girl who cradles it lovingly in her arms. In this image, Seymour records that a child's need to express love through interaction with toys does not diminish even when the toy is deficient.

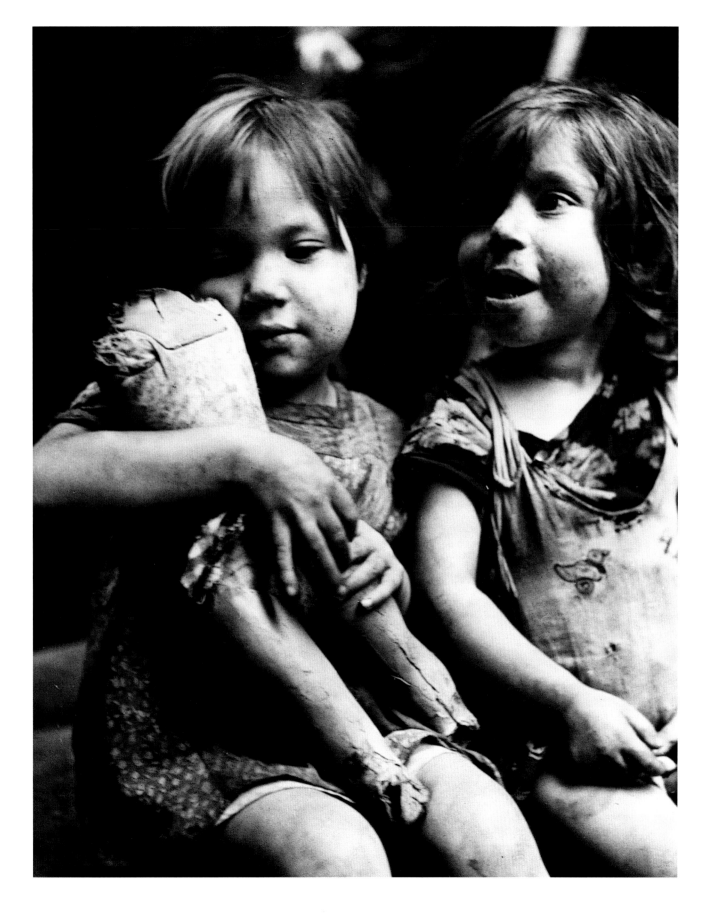

25 1948 Children in a State Kindergarten, Budapest, Hungary.

Children playing would have been an irresistible subject for Seymour under any circumstances, but on this occasion he was documenting the children as healthy beneficiaries of the UNICEF milk supply programme. Seymour has chosen to contrast the fresh-air environment of the children with that of their parents, working in the grim textile factory of Fesus Fono that rises up in the background.

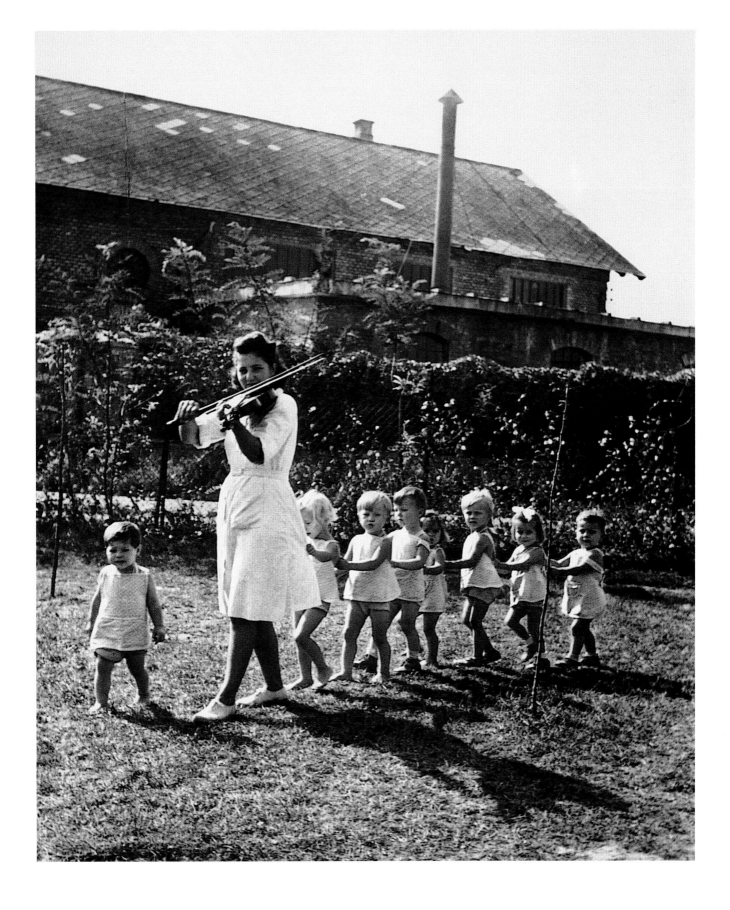

1948 Village of Pillis, near Budapest, Hungary.

Adept at capturing children's emotional responses, Seymour showed this child as her working mother was about to leave her at a community kindergarten. In photographing children, he typically took his shots at their own level, heightening a sense of connection with their world. He was especially attuned to gestures, not only because they could reveal much about the emotions of his subjects, but also because they could contribute to the composition of the image. In this photograph, the mother's hand rests protectively on the girl's head and leads the viewer to her face.

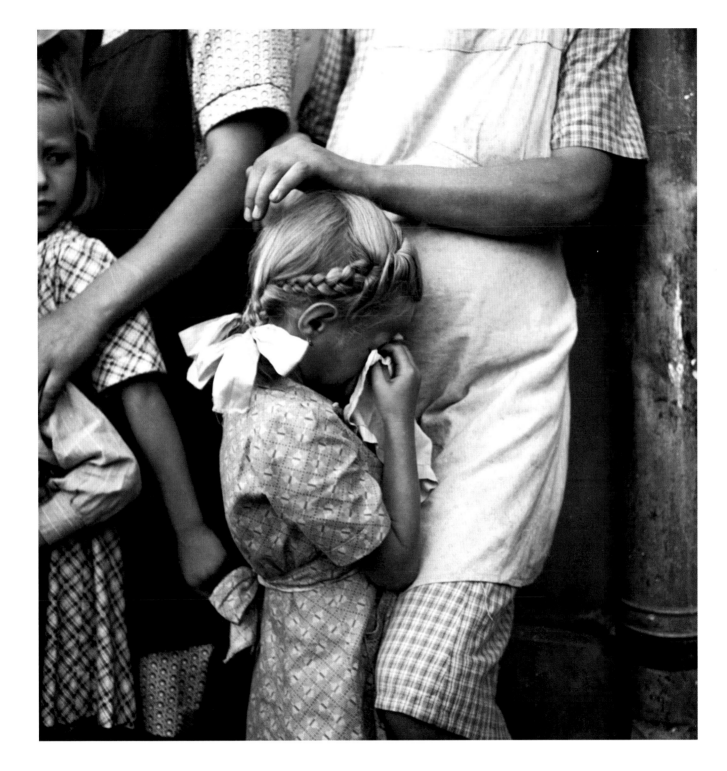

27 1948 Children Playing in a Suburban Park near Budapest, Hungary.

Seymour masterfully chose a point of view for this image that shows these children as having their own world separate from that of the city, visible in the distance. Their play is of the moment, without regard for the preoccupations of daily life. Within the design of the photograph, the circle formed by the children radiates its energy in all directions.

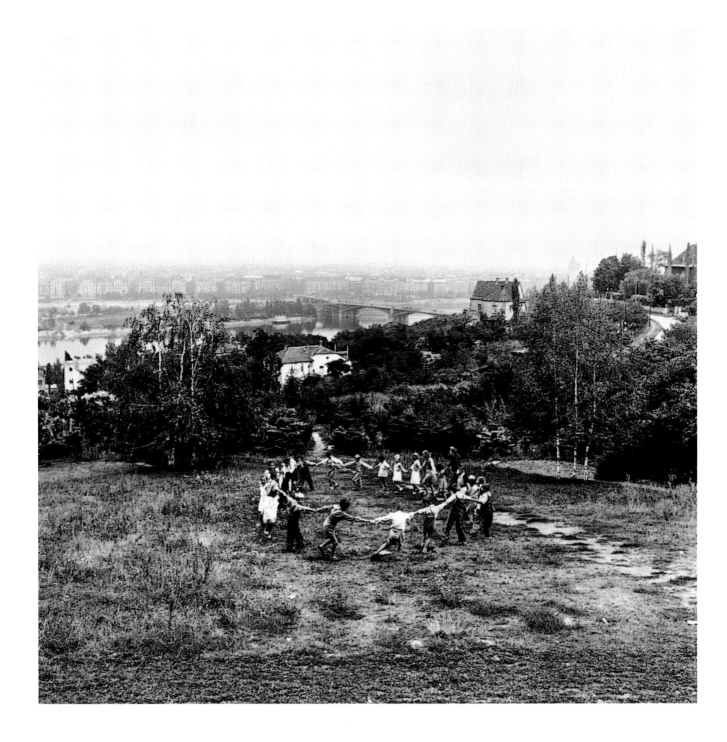

28 1948 Italian Mother and Children at the Beach, Naples, Italy.

Seymour loved Italy, and spent as much time there as he could. He had
gone there originally to photograph children for UNICEF in 1948, but
came back to make images for Anne Carnahan's *The Vatican: Behind the Scenes
in the Holy City* (1949). The indomitable Italian spirit, as displayed by this
woman surrounded by her children at the beach, appealed to him greatly.
The image is animated and full of life, and, as spontaneous as it appears,
it is exceedingly well composed, with the children aligned to lead viewers
to the primary element, the mother.

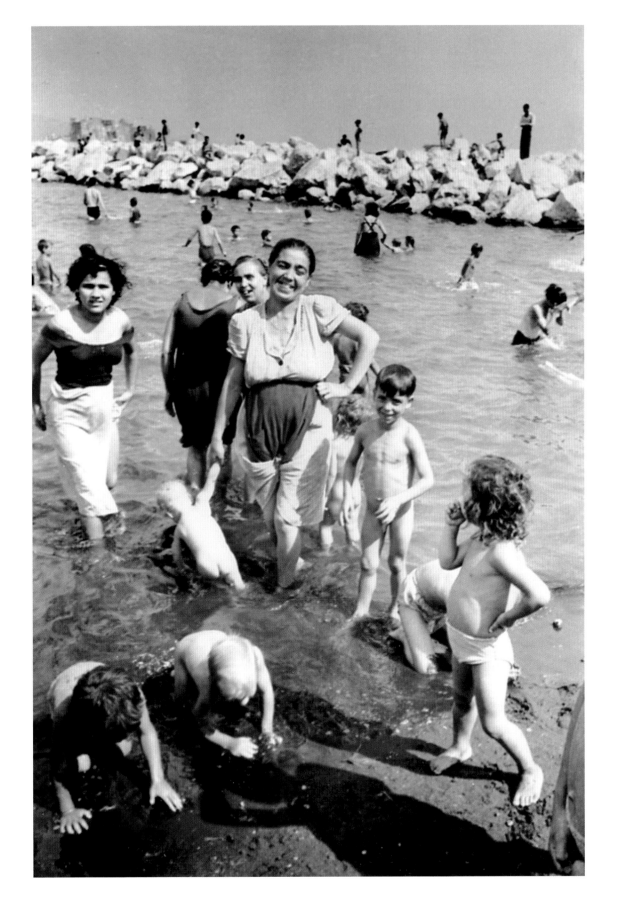

1949 Election Rally, Munich, Germany.

After his work for UNICEF, Seymour did not return to Eastern Europe, preferring instead to cover events that were more hopeful and forward-looking. Seymour photographed this political rally in Munich mindful of those held by the Nazis just a few years earlier. The three zones of post-war Germany occupied by the United States, Britain and France were now democratically transformed and new German political parties were permitted to function freely. In choosing as his viewpoint that of the war-wounded flag bearer, it is as though Seymour was saying that while Germany had been crippled, it was still able to get up and move on.

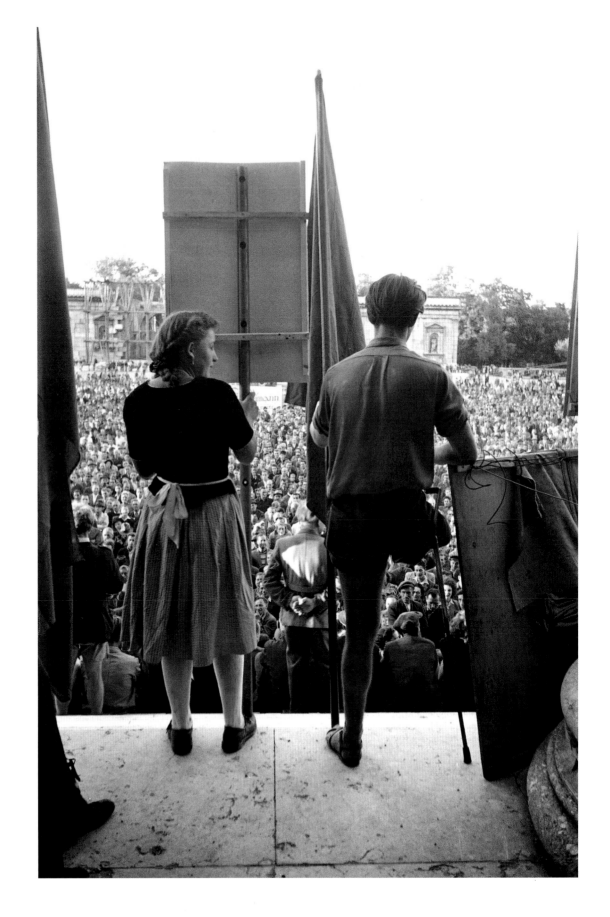

1949	Winston Churchill at the Council of Europe, Strasbourg, France.

Winston Churchill was highly esteemed for his wartime leadership. However, his party did not retain control of the British parliament in 1945, and it was as opposition leader that he supported, among other issues, greater cooperation in Europe through the formation of the Council of Europe. Seymour photographed Churchill looking intense while attending the first meeting of the Council. Europe was changing rapidly after World War II, and Seymour knew where he had to be in order to photograph important events. Most of his stories were self-assigned, in keeping with the ideals of Magnum, but he may have taken an assignment to cover this meeting.

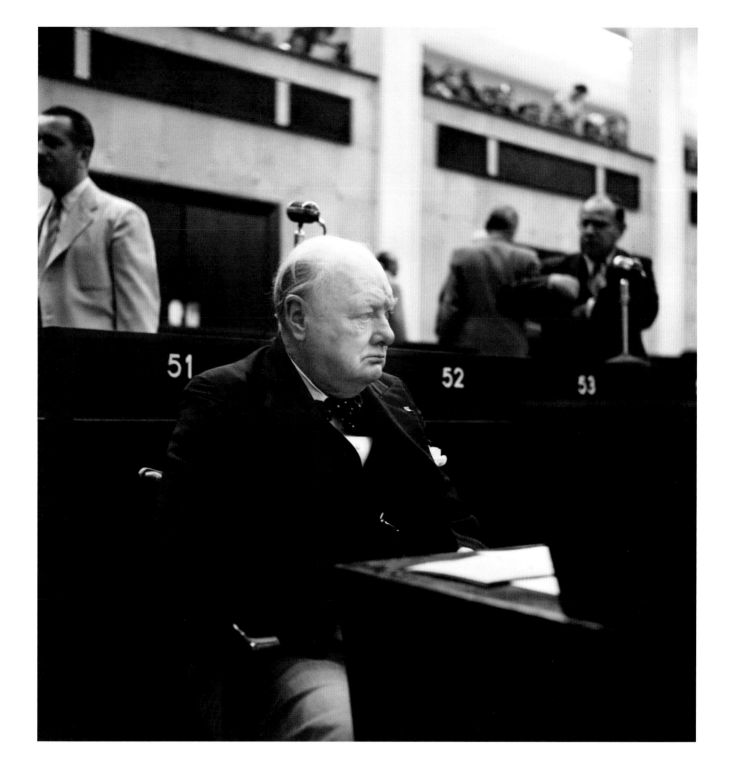

1950 Peggy Guggenheim at the Palazzo Venier dei Leoni, Venice, Italy.

Legendary art patron and collector Peggy Guggenheim moved from New York to Venice in 1947, and exhibited her extensive collection of modern art the next year in her own pavilion at the Venice Biennale. In 1949, she purchased and refurbished her dream house on the Grand Canal, the Palazzo Venier dei Leoni, an unfinished building begun in 1748. Photographed by Seymour on the deck that she had added for sunbathing and entertaining, Guggenheim wears gold-rimmed butterfly sunglasses and is surrounded by her beloved Tibetan terriers. By including personal details about his subjects Seymour was able to make them more human and less removed from the viewer.

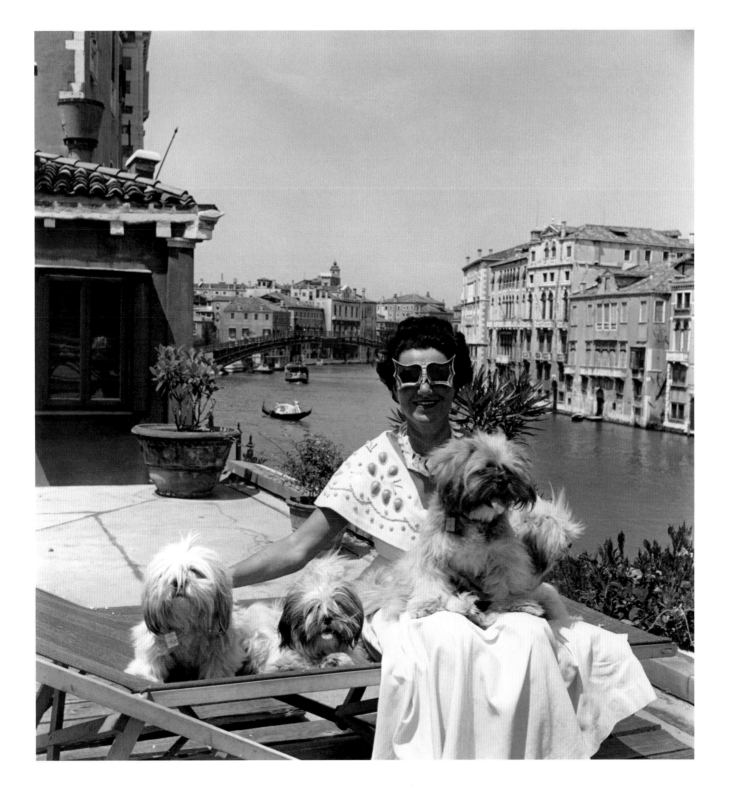

1950 Boy with a Toy Gondola, Venice, Italy.

A place of great beauty that had not been damaged by the war, Venice was one of Seymour's favourite locations in Italy. His visits there prompted a playfully creative edge to his observations of Italian life, illustrated by this image of a boy guiding his tethered toy gondola through the water. The finely-made toy is in contrast to the crudeness of the boat in which the boy crouches. This image was used on the cover of the Swedish magazine *Vi* in 1951.

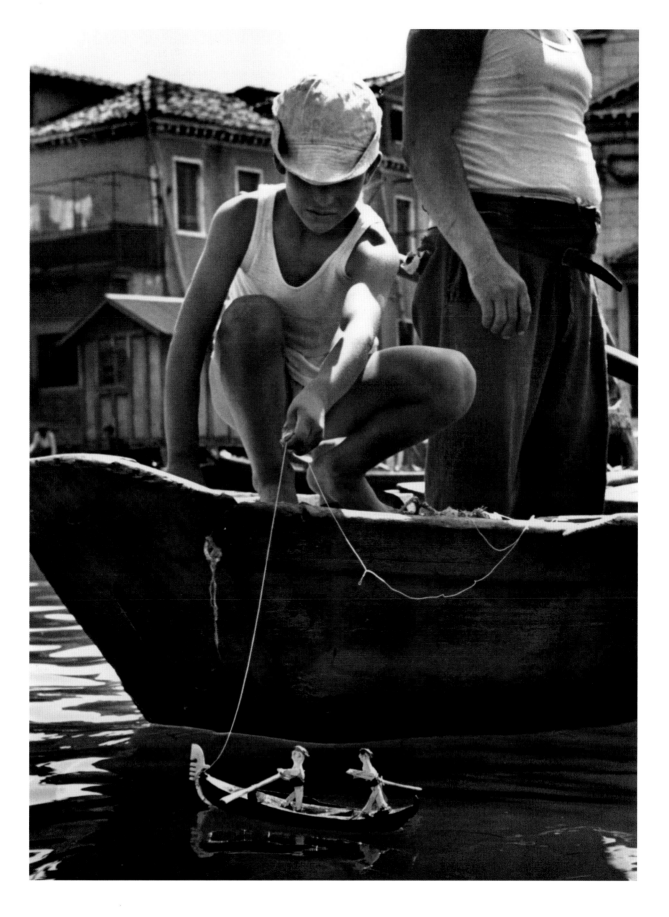

33 1951 Celebration of First Communion, Venice, Italy.

Fascinated by religious festivals and rituals, and their role in the human condition, Seymour photographed them whenever he had the opportunity. Catholic Italy was a visual feast for him. In this image he captured the joyous nature of the occasion both through the interactions of the children and the smiles of the adults in the background.

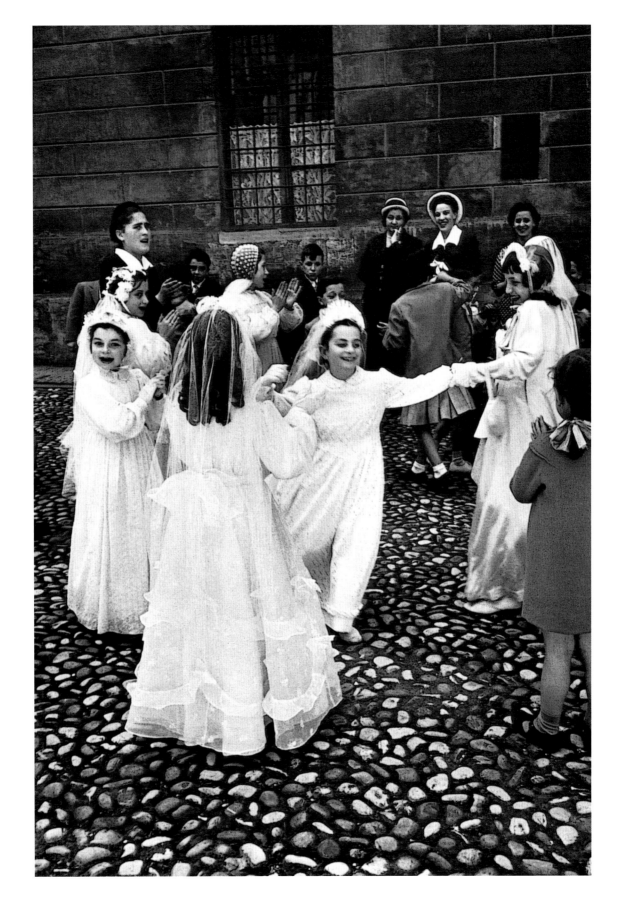

1951 Mykonos, Greece.

A carefree little boy, framed back-lit in a cool alleyway, captures what Greece represented to Seymour: 'a sort of escape from the world in which we are living, to wander through the ancient Greek ruins and to sail around the islands. One gets philosophical looking at the remnants of great civilizations, there is another [advantage] to being in Greece ... there is no way to read the papers. Outside Athens the isolation is perfect and wonderful.' Seymour fell so much in love with Greece after working there for UNICEF in 1948 that he continued to make regular visits both for vacations and in search of stories.

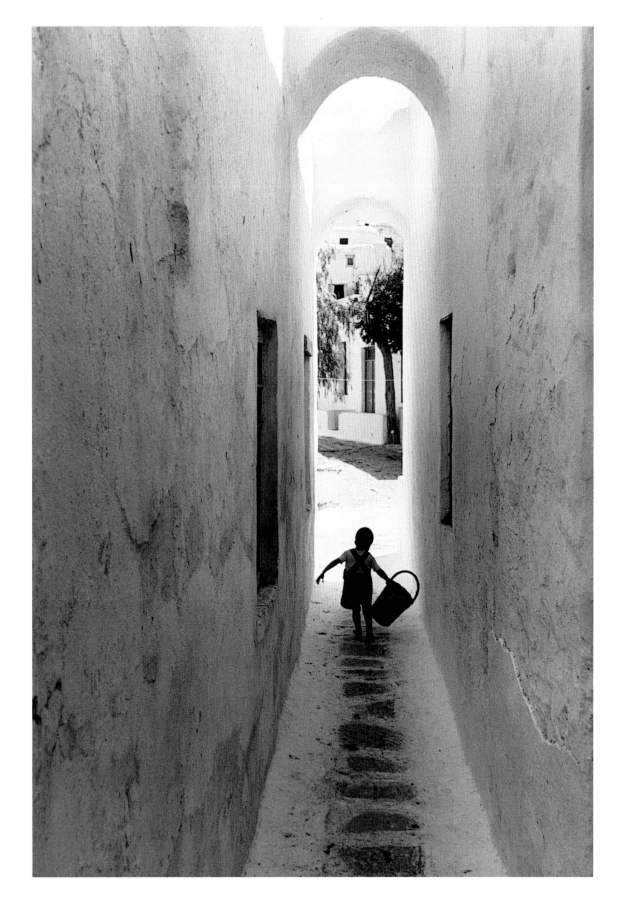

35 1951 Mykonos, Greece.

Like his close friend Cartier-Bresson, Seymour carefully balanced the elements in his images, as in this photograph of an elderly Greek woman walking to church. Seymour made the exposure when the woman was positioned precisely in equilibrium with the other parts of the composition. Seymour's fascination with the rituals of religion was a continuous thread throughout his work.

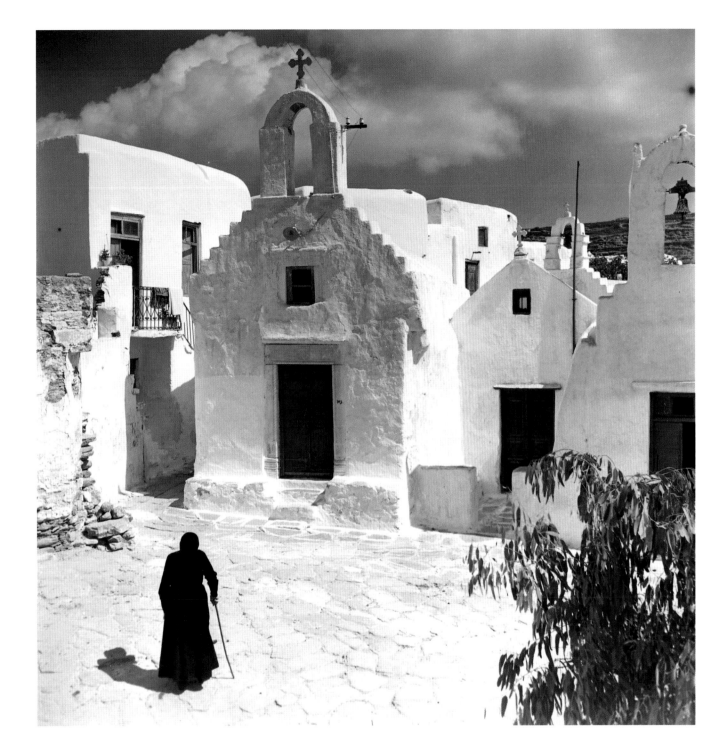

1951 First Child Born in the Settlement of Alma, Israel.

After it was founded in 1948, Seymour visited Israel regularly, recording the lives of immigrants in small rural settlements. Seymour saw Israel as a beacon of hope for those Jews without countries to call home. This optimistic image shows Eliezer Trito, an immigrant recently arrived in the new settlement of Alma in northern Galilee, holding up his first child, Miriam.

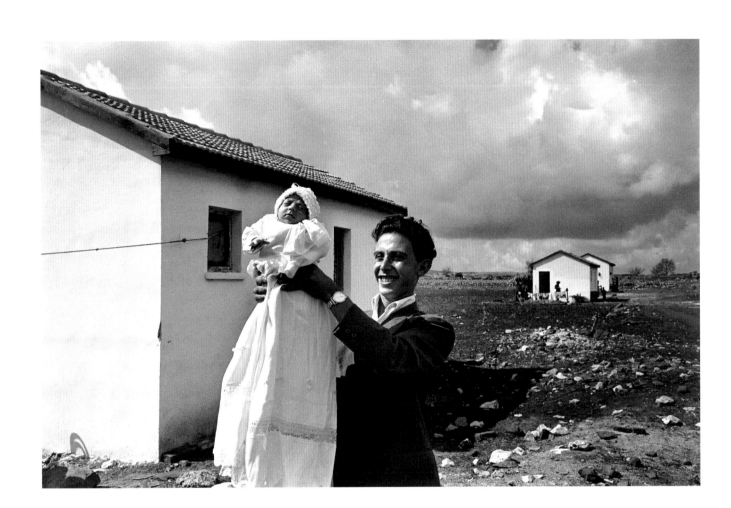

37 1951 Young Woman Preparing for Sentry Duty, Haifa, Israel.

Seymour's wonder and admiration for the fledgling Jewish State was revealed in many of the photographs he made there, including this image of a young woman carrying a rifle. At its founding, Israel was unique in having military conscription for both men and women. While this strong portrait suggests the image of a warrior, her demeanour is as gentle as the light in which Seymour photographed her.

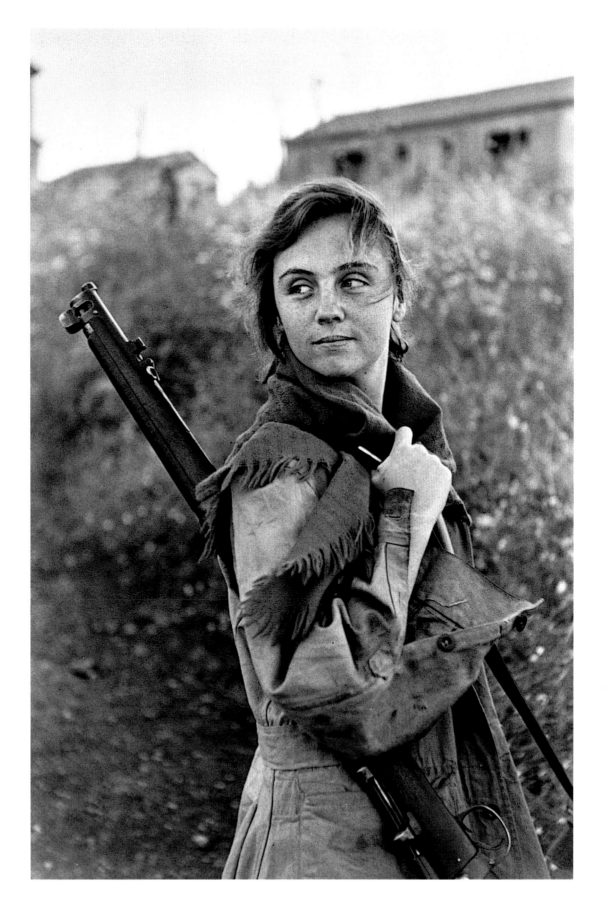

1952 Wedding in the Border Regions, Israel.

Particularly symbolic of the new state of Israel is Seymour's image of a wedding among the barren hills in the border regions. Instead of posts holding up the traditional Jewish wedding tent, or *huppah*, guns and pitchforks act as improvised supports. Israelis had to fight off attacks from Arab neighbours, while raising crops and starting families. Seymour had a special affection for Israel as both family members and friends – who had survived the war and the Holocaust – had settled there.

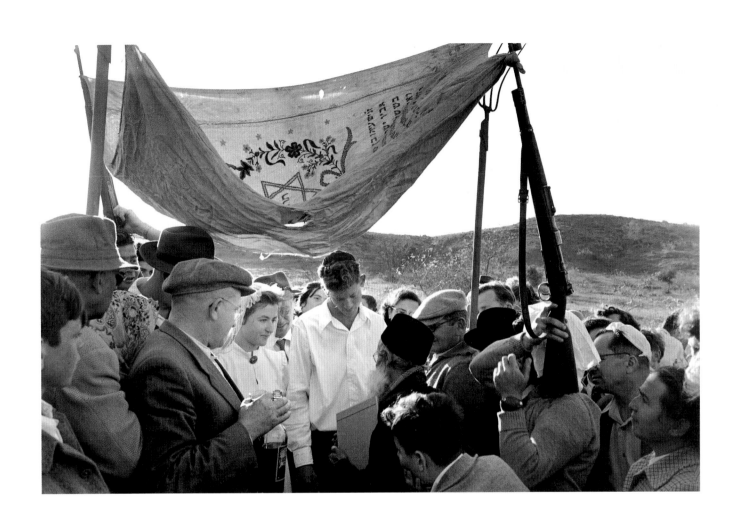

1952 Young People at a Nahal Kibbutz, Huleh Valley, Israel.

The Nahal, or Fighting and Pioneering Youth, was a military group established by David Ben Gurion during the 1948 Arab–Israeli war. The group combined military service in a combat unit with civilian service in a newly-founded settlement. Members of a particular Nahal unit became closely bound together, and, after the military obligation, many returned to the settlements in which they had performed the civilian portion of their service. Even though he was an outsider, Seymour photographed perceptively the in-group behaviour of Nahal members.

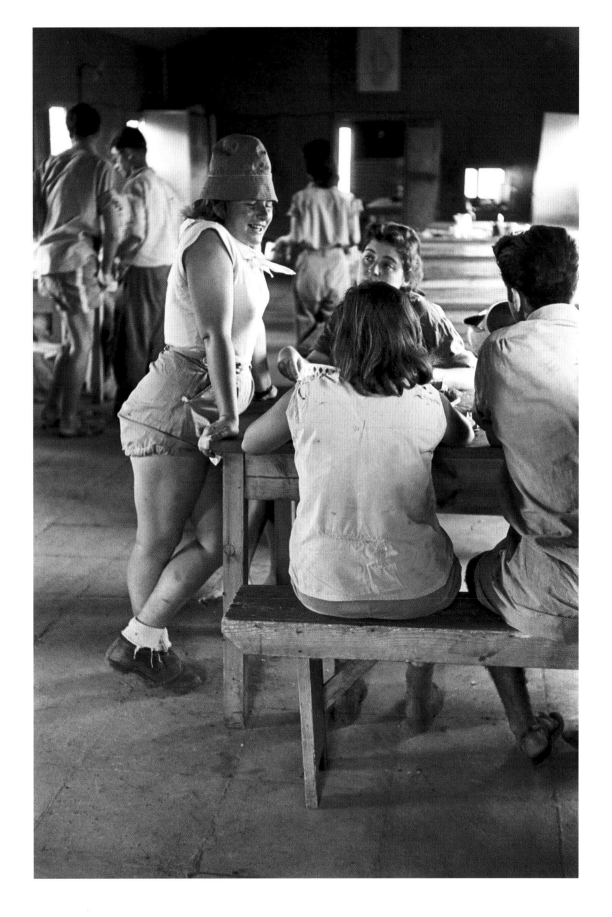

c.1952 Ingrid Bergman.

Colour photographs became more commonly reproduced in magazines by the late 1940s as printing technology began to catch up with magazine consumers' thirst for vivid imagery. Seymour began making colour transparencies of his celebrity and human-interest stories in 1948. Many American motion pictures were then being made in Europe and coverage was in demand from magazine editors. One of Seymour's favourite subjects was actress Ingrid Bergman, who trusted his integrity as a photographer and granted him access not given to other photographers, partly because he was recommended by Capa who had shared a romance with Bergman between 1945 and 1948.

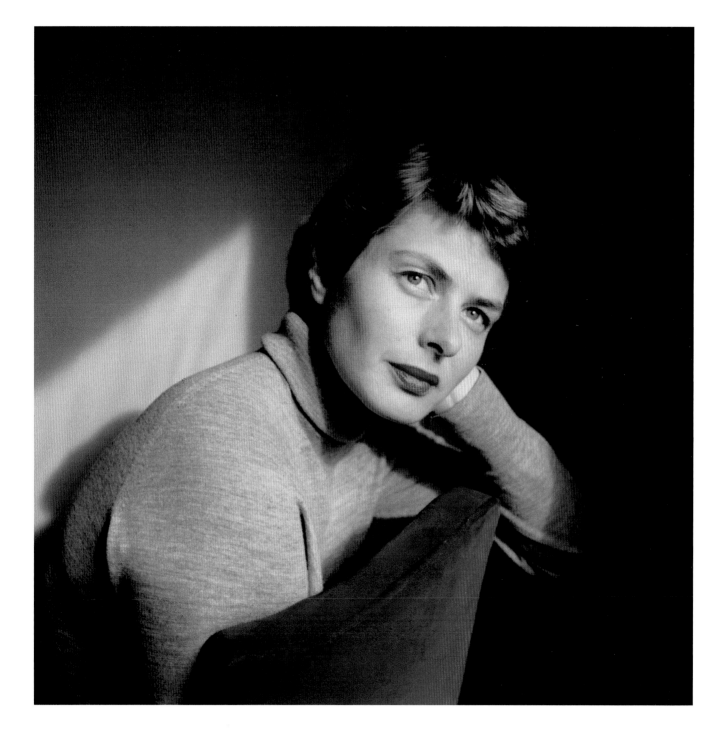

41 1953 Kirk Douglas on the Set of *The Act of Love*, Paris, France.

Kirk Douglas crossed the Atlantic for the first time in 1952 to spend eighteen months working on three films – *The Juggler*, *The Act of Love* and *Ulysses* – in Israel, France and Italy respectively. In need of a European assistant and someone to handle his publicity, he was advised to hire Anne Buydens, who had just finished a similar job for John Huston. Seymour, who was covering the making of *The Act of Love*, did Douglas the favour of arranging for him to interview Buydens. Douglas and Buydens were married in 1954. As demonstrated by this image of Douglas, depicted here as a man of distinction, portraiture was intuitive for Seymour. Often Seymour had two Leicas with him, one for colour film and the other for black and white. Documenting the making of movies with still photographs had gradually become common practice since the 1930s, and Seymour was there to give the public inside glimpses of movies soon to be released.

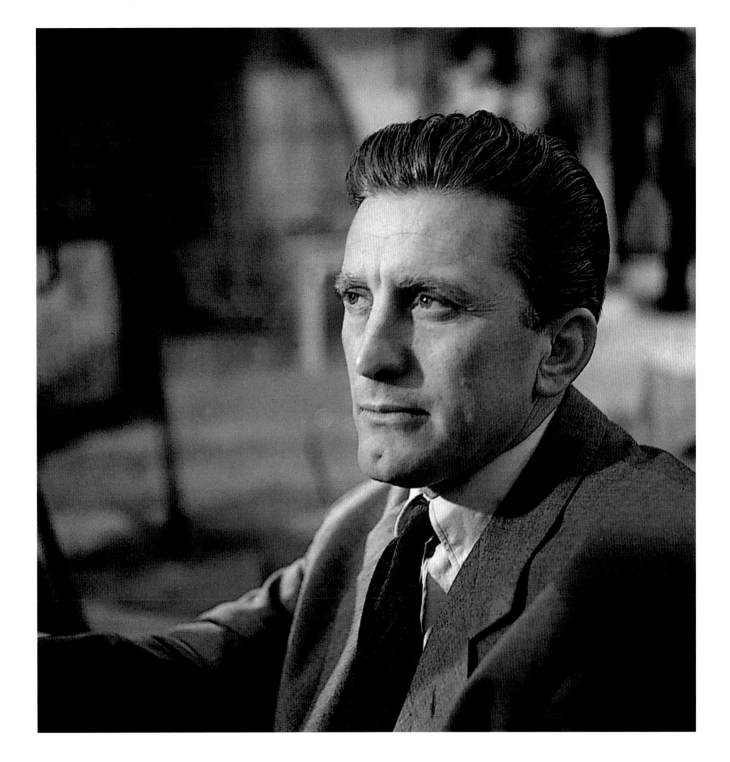

1953 Earthquake, Argostoli, Cephalonia, Greece.

In Greece on a Magnum assignment to photograph Queen Frederika, Seymour's appointment was cancelled when a powerful earthquake struck the west coast islands of Cephalonia, Zakynthos and Ithaca. He arrived at Cephalonia quickly enough to document the immediate aftermath of the earthquake. His adeptness at story-telling reveals the human dimension of the tragedy. Later, he wrote: 'If one believed in anything, it would be the solidity of the ground on which we stand, and if that starts to jump, what can we trust?'

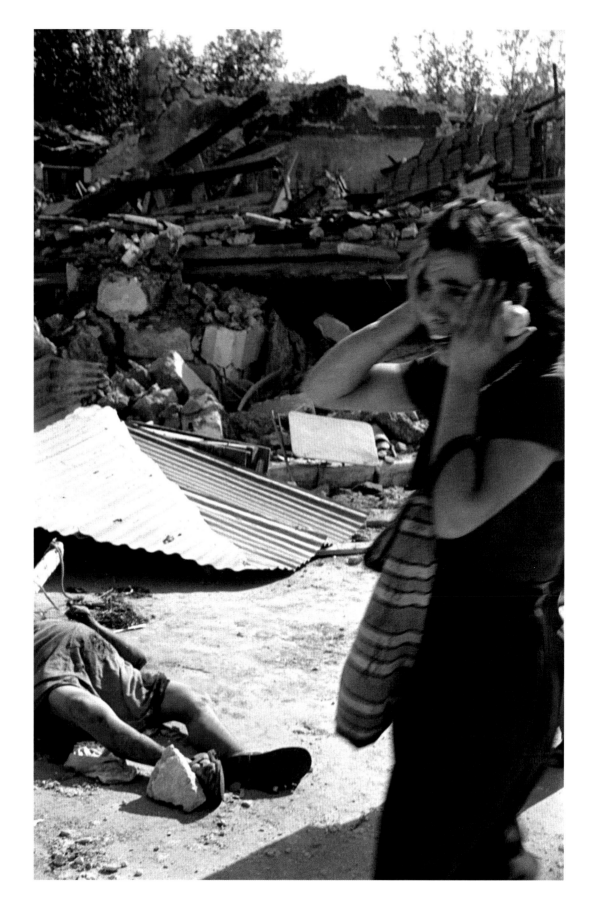

43 1954 Monastery, Meteora, Greece.

Free to make assignments for himself, curiosity brought Seymour to the
beautiful Meteora valley, with its many monasteries, to indulge his fasci-
nation with religious subjects. The monasteries provided the raw material
for a whole portfolio of photographs. Ever the humanist, Seymour uses the
cat in this image to reveal the humanity of the man.

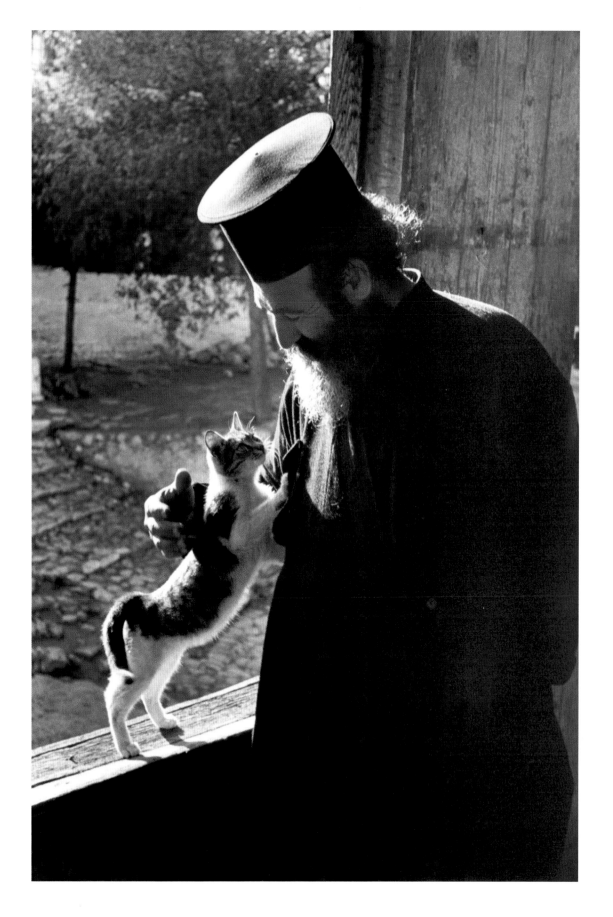

44 1954 Boy Lighting Candles at a Children's Reception, Israel.

Seymour combined two of his favourite subjects in this image: Israel and
children. Between 1948 and 1956, approximately 850,000 Jewish immigrants
arrived in Israel, mostly from Central and Eastern Europe. Many of these
immigrants were displaced persons, such as the orphans in this photograph,
who were greeted at a reception with a candle-lighting ceremony to begin
the transition into their new country. 'At the children's reception,' Seymour
said, 'the little boy in the sailor suit is invited to light four candles symbol-
ically – this helps break the ice.'

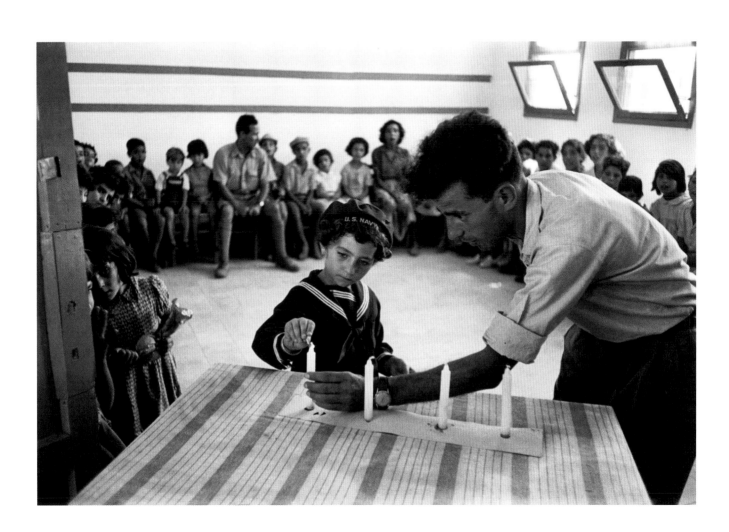

45 | 1954 | Gina Lollobrigida, Rehearsing for *Trapeze*, Rome.

Lollobrigida, having achieved great success and many awards for her European films, moved to Hollywood in 1949. However, Howard Hughes, who signed a contract with her and then declined to take up the option of casting her in films, barred her from working. When the contract lapsed in 1956, she starred in *Trapeze* opposite Burt Lancaster and Tony Curtis. Seymour's colour image of Lollobrigida rehearsing for the film is as notable for its simplicity as for its elegance. Naturalness was a hallmark of Seymour's portraits, whether of famous film stars, such as Lollobrigida, or orphaned children. The essence of the subject emerges from the image without artifice or pretension.

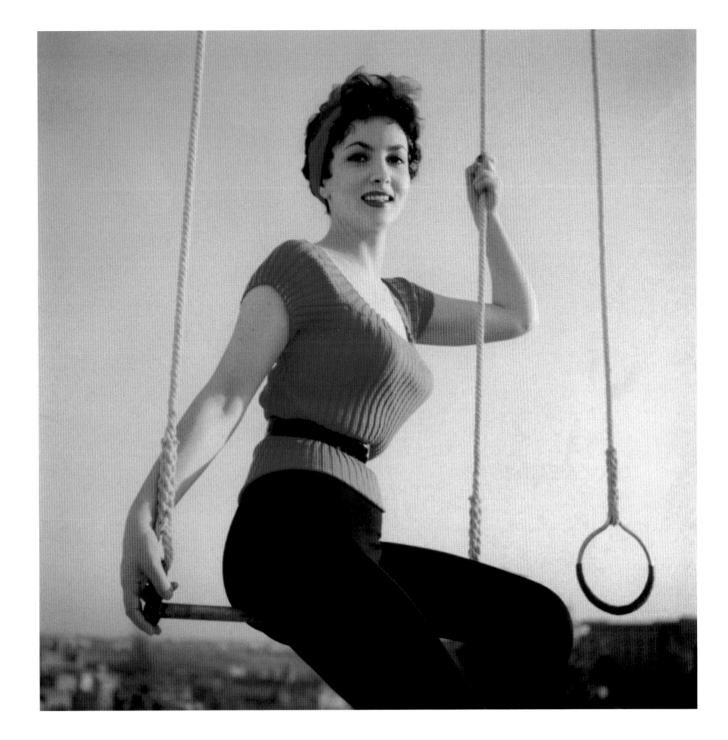

1954 Joan Collins, Working on *Land of the Pharaohs*, Rome, Italy.

Joan Collins, who made her stage debut at nine years old and wrote her first novel at eleven, was just twenty-one when Seymour photographed her. Seeking simplicity in the image, Seymour draped furniture with white terry cloth and used the graphic quality of her black dress as the basis for the composition.

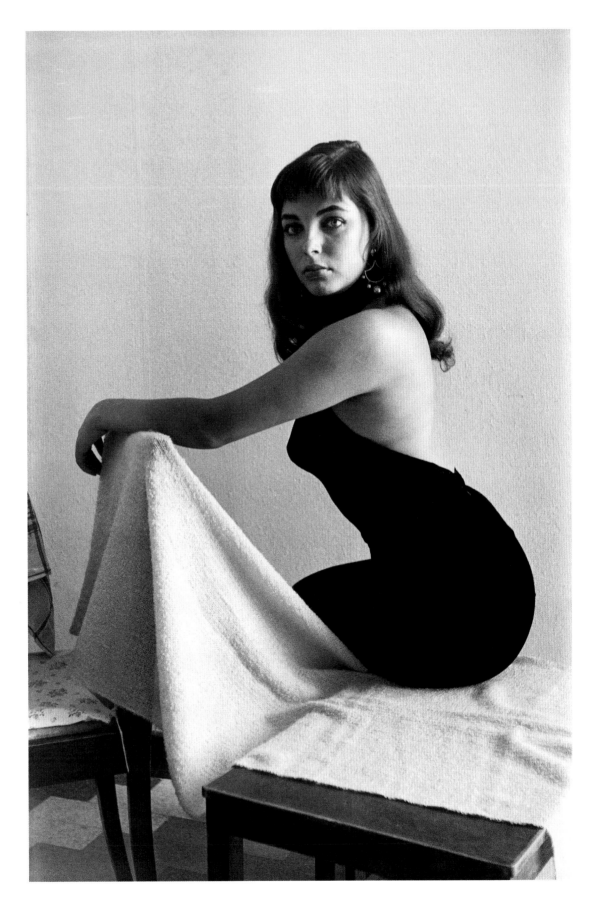

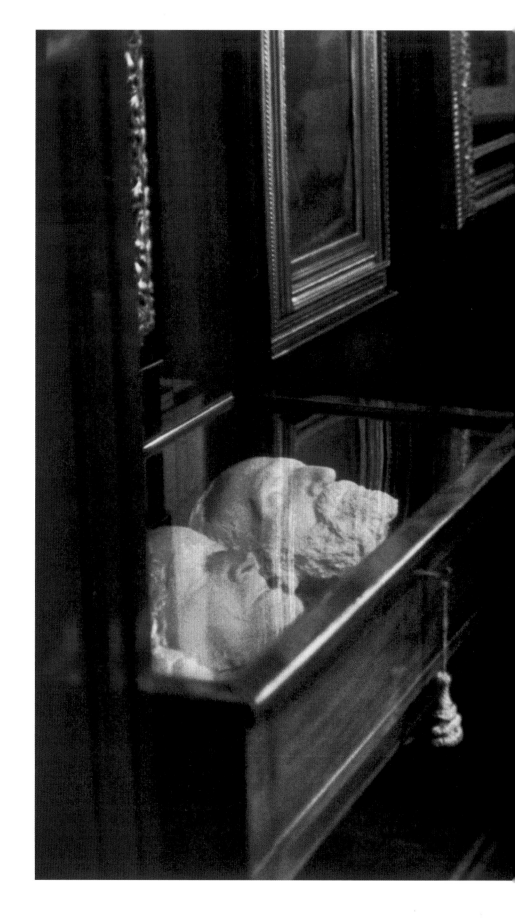

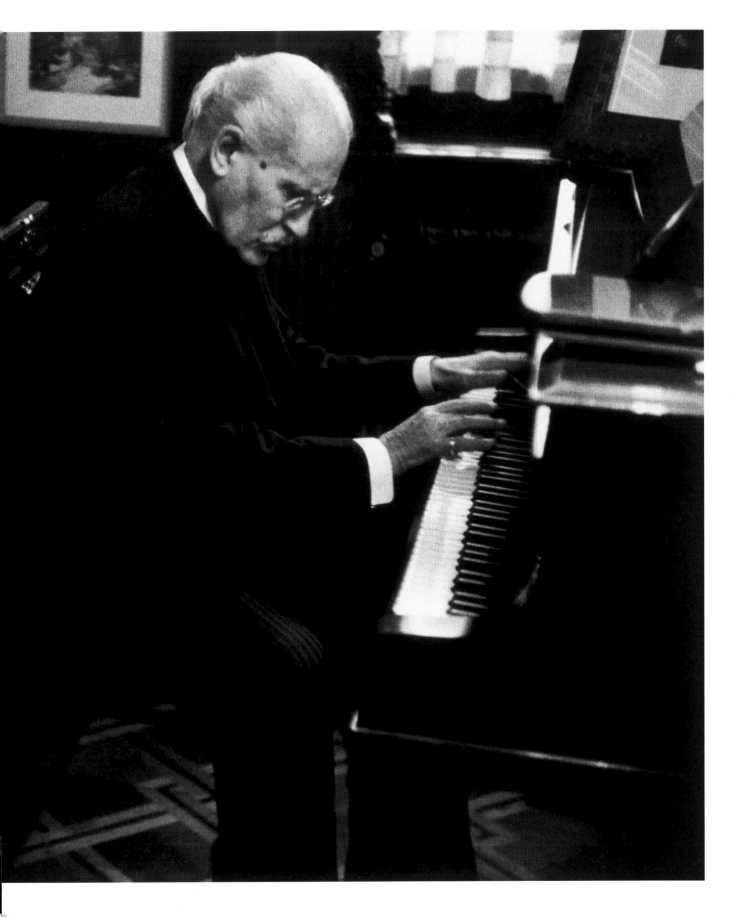

Toscanini, the great Italian conductor of opera and symphonic music, was as fanatical about perfection in musical performance as he was devoted to the music of Beethoven, Wagner and Verdi, whose death masks can be seen in the case behind him. Generally he refused all requests to be photographed, however, his daughter, the Countess Castelbarco, invited Seymour to photograph Toscanini for his Christmas card. The resulting image draws a symbolic relationship between Toscanini and the three great masters.

Seymour described his first encounter with Loren: 'We talked over the phone, and ... she invited me over for a Sunday morning early meeting. I found her in bed in a dark blue negligée, although she was talking on the phone. She got up and changed costume [and] we went to a balcony of her apartment and I had nothing else to do but record a stream of poses which somehow met my memory of wartime pin-ups. All this was done with a touch of irony and maliciousness. We had a running conversation about "La Grande Marilyn" (Monroe), the goddess that had inspired her.'

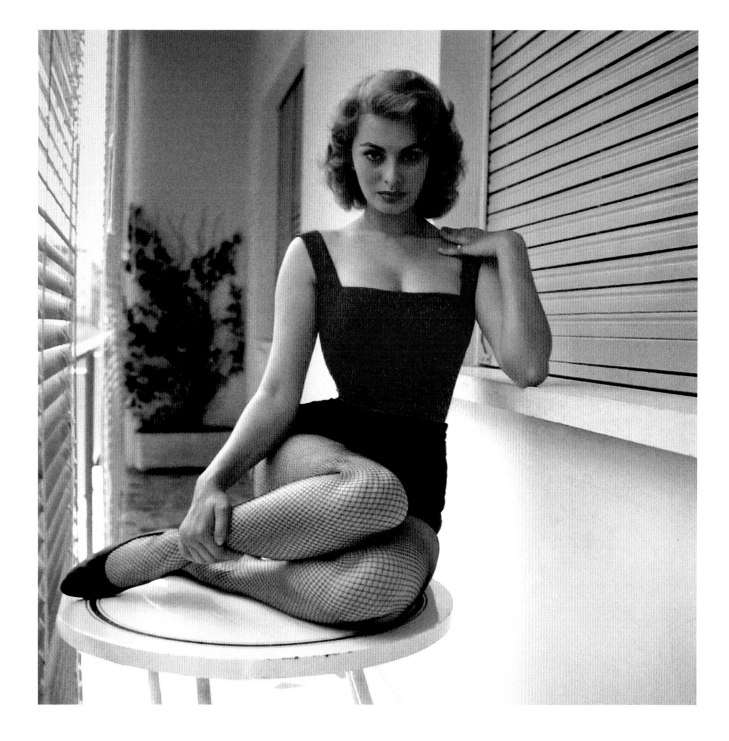

49 1955 Good Friday Observance, Sicily, Italy.

Seymour spent much of his time in Italy during the 1950s. His sensitivity
to history, tradition and religious ritual is especially notable in his Italian
images. This image is animated by his ability to make icons look more
like human beings than statuary, and the overall sharpness of the image
heightens the sense of a whole community involved in a procession,
bound together by their faith.

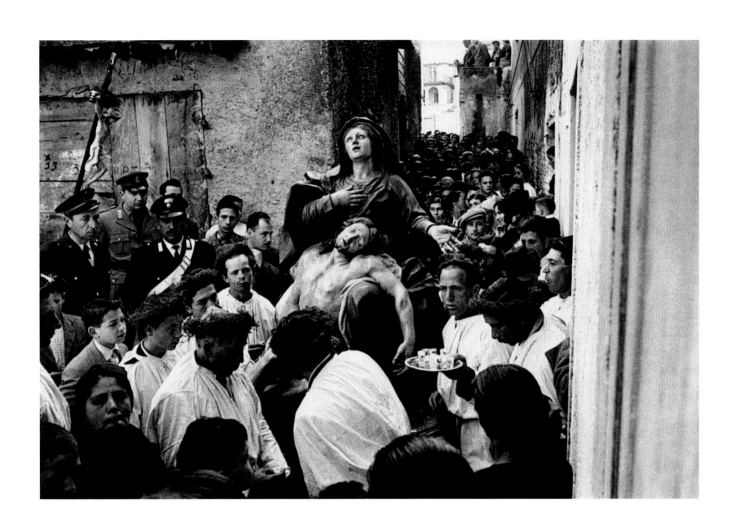

50 1955 Bernard Berenson, Borghese Gallery, Rome, Italy.

Noted for his interest in ideal form, art historian Bernard Berenson did not appreciate sexuality in art, or art much after the Renaissance. When he visited Peggy Guggenheim's pavilion at the 1948 Venice Biennale, she told him that she had read all of his books and appreciated them. Berenson condescendingly asked why she bothered with modern art and to whom she could possibly bequeath her collection. To his consternation, she responded: 'To you, Mr Berenson.' It is with wit and irony that Seymour portrays Berenson, aged ninety, contemplating the sensuous nude sculpture of Pauline Borghese by the neoclassical sculptor Antonio Canova. Like his earlier portrait of Picasso, posed with his painting *Guernica* (no. 10), Seymour connects his subject to the artwork as though Berenson is a participant in a dialogue. The conversational tone of Berenson's many books on art seems to have been captured in Seymour's portrait of the great historian and critic.

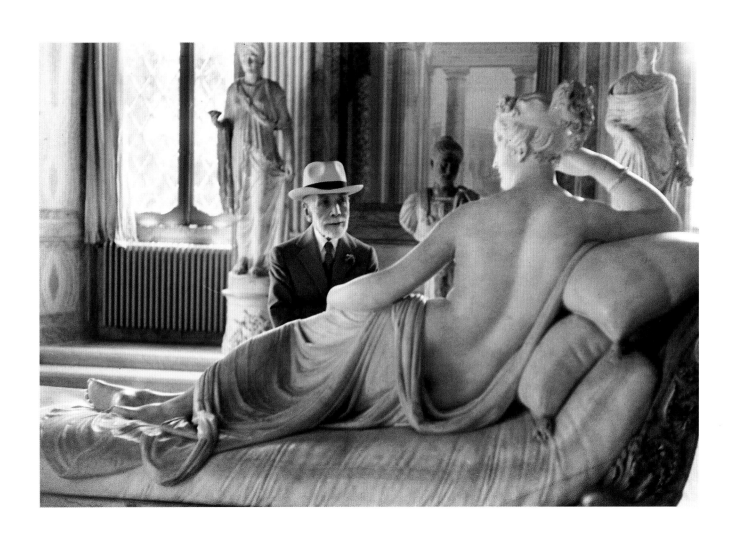

1956 Audrey Hepburn, Working on *Funny Face*, Paris, France.

Seymour photographed Audrey Hepburn during rehearsals for *Funny Face*, her fourth major film. He highlighted the qualities for which she had become famous – delicate yet strong, boyish yet feminine, and down-to-earth yet aristocratic. In *Funny Face*, she played an existentialist bookseller who was absorbed in books, but was transformed into an haute-couture fashion model by co-star Fred Astaire. Seymour had done much for child welfare through his photographs for UNICEF and Hepburn was also to use her celebrity status to bring world attention to children in need and UNICEF in the 1980s and 1990s.

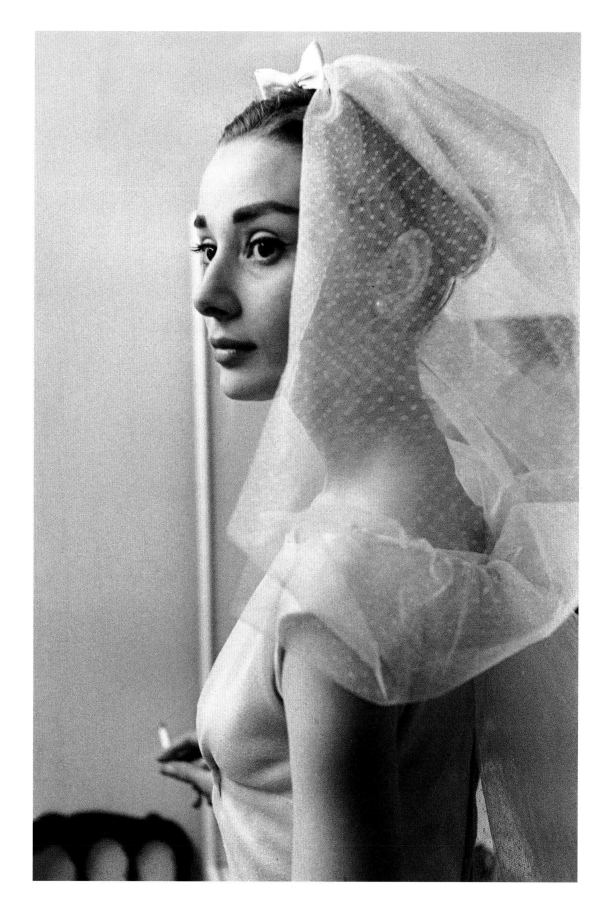

1956 Richard Avedon and Fred Astaire on the Set of *Funny Face*, Paris, France.

On location in the Tuileries Gardens for the making of *Funny Face*, famed fashion and portrait photographer Richard Avedon gave advice to actor/dancer Fred Astaire, whose role in the film was loosely based on Avedon himself. The film follows an intellectual bookseller, played by Audrey Hepburn, who is enticed to become a Paris fashion model despite her initial misgivings. Director Stanley Donen had to shoot the film in the rain after waiting days for fair weather, and Astaire and Hepburn performed their carefully rehearsed scenes and dances in the mud. Seymour covered the making of the movie and, like Avedon and Astaire, was exacting in his art as demonstrated by this image. He captured not only a telling moment in the genial relation-ship between the two men, but also an artful arrangement of the subjects while an assisant held an umbrella to keep rain off the view camera.

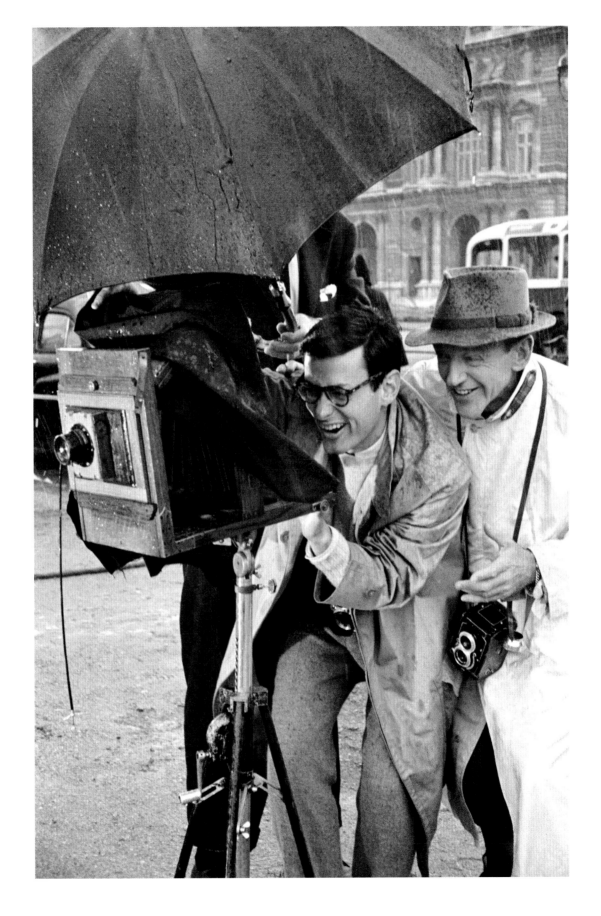

53 1956 Port Said During the Suez Crisis, Egypt.

The climax of Seymour's life, both professionally and personally, was the 1956 Suez Crisis. Egyptian leader Gamel Abdel Nasser had nationalized the Suez Canal, closing it to oil shipments destined for Israel. Under this immediate and other long-term threats from Arab states, Israel mobilized its troops and occupied Sinai up to the canal. British and French troops landed at Port Said to re-internationalize this strategically important route. Seymour arrived after the fighting was over, but made powerful images of the effect of the war on the local people. Using symbolism, as he had done throughout his career, Seymour seemed to be saying that the shadow of war hung over the Egyptians even after the Suez Crisis was over.

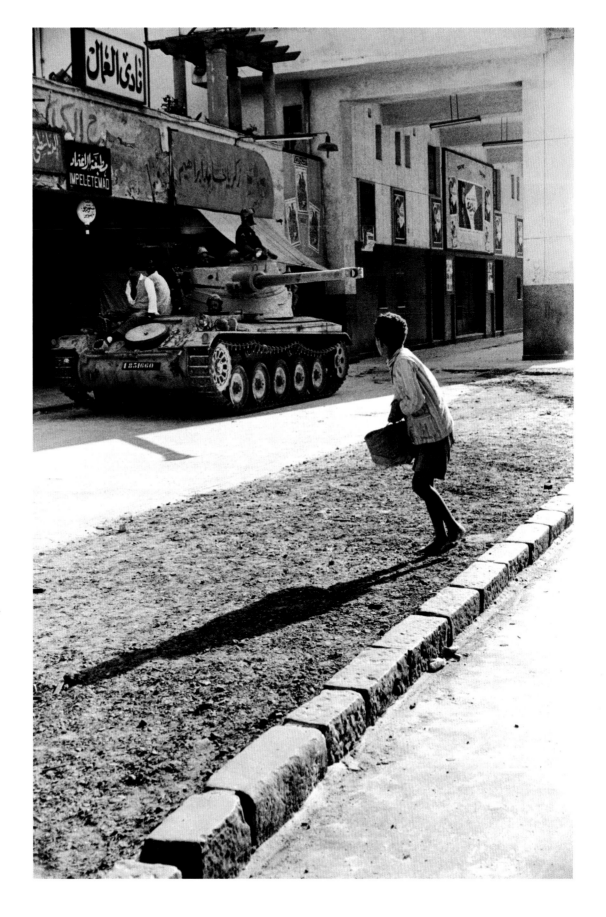

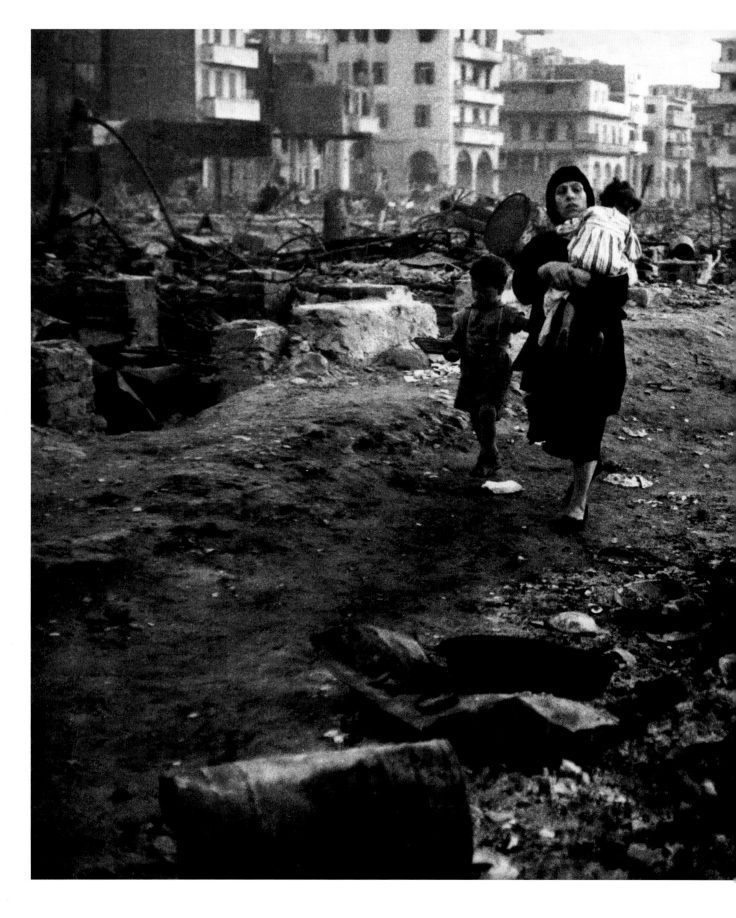

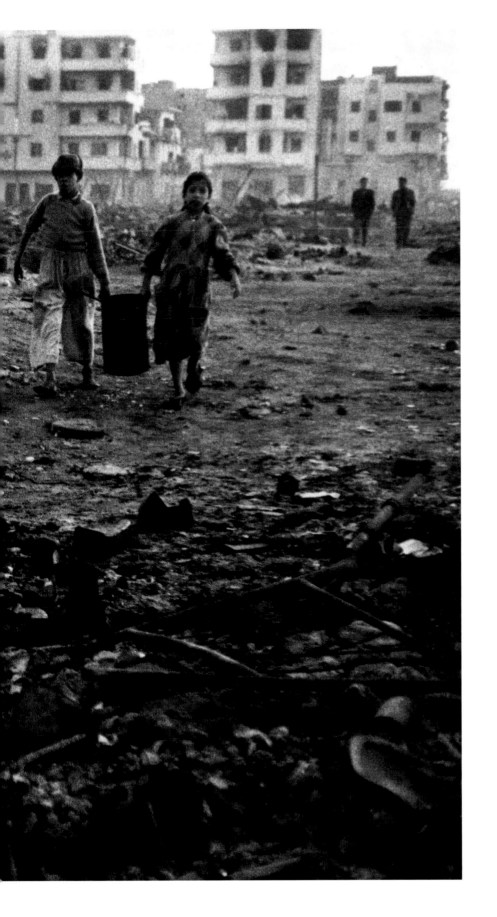

54 *previous page* 1956 Inhabitants in the Wreckage of Port Said, Egypt.

Always concerned for the plight of children, Seymour photographed this Egyptian mother and her family foraging for food and water amid the devastated buildings of Port Said during the Suez conflict.

55 1956 Egyptian Prisoners at El Gamel Airfield, Port Said, Egypt.

Among the last images that Seymour was to make was this one of Egyptian prisoners being taken to El Gamel airfield. Their task was to remove the refuse created when French paratroopers landed there to support re-internationalization of the Suez Canal. Suez was to be the site of Seymour's tragic death. He was killed while covering an exchange of wounded prisoners of war just days after the signing of the armistice.

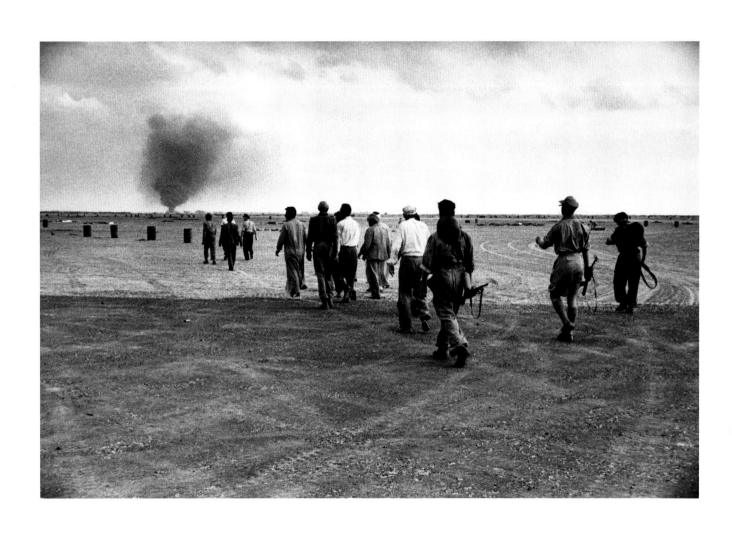

1911	Born Dawid Szymin on 20 November in Warsaw, Poland, the son of a prominent publisher of Hebrew and Yiddish books.
1914	Forced to leave Poland for the Ukraine by World War I bombing. When the war overtook his family again, they moved to Odessa, Russia.
1919	Returned to Warsaw after the war.
1929	Passed baccalaureate and graduated from Ascolah Gymnasium in Warsaw.
1929–31	Attended Leipzig's Staatliche Akademie für Graphische Künste und Buchgewerbe, graduated, and returned home.
1931	Arrived in Paris to study chemistry and physics at the Sorbonne.
1932	Became Paris representative for Ruan, a Warsaw press and publicity photography firm. Sought work in Paris from family friend David Rappaport, who operated the picture agency Rap. Photographed views of Paris, as well as fishermen and miners in northern France.
1934	Became staff photographer for *Regards* magazine.
1935–6	On assignment to cover the activities of the Front Populaire in France.
1936–9	On assignment to cover the Spanish Civil War.
1938–9	Worked through Alliance Photo and Black Star agencies.
1939	Accompanied the 1,000 Spanish refugees aboard the S.S. *Sinaia* to Mexico. Went to New York in September. Established Leco Photographic Service with partner Leo Cohn on 42nd Street.
1942	Volunteered to help the United States war effort. Drafted into the US Army and trained in military intelligence at Camp Ritchie, Maryland. Also trained as a motion picture cameraman for the US Army Signal Corps at Astoria, Long Island, New York.
1943	Received his Certificate of Naturalization as a US citizen. Sent to England to work as photo-interpreter. Promoted to rank of Sergeant in the US Army.
1944	Promoted to 2nd Lieutenant. Returned to the US in December and was discharged from active duty in the army.

1947 Returned to photography with assignment in Europe for *This Week* magazine entitled 'We Went Back'. Co-founded Magnum Photos with Robert Capa, Henri Cartier-Bresson and George Rodger.

1948 Commissioned by United Nations International Children's Emergency Fund (UNICEF) to photograph Europe's postwar children. Travelled extensively through Poland, Hungary, Germany, Czechoslovakia, Greece and Italy. Began photographing in colour.

1949 Published 47 photographs in *The Children of Europe* and contributed images to *The Vatican; Behind the Scenes in the Holy City*. Exhibited photographs in *Quelques Images de Hongrie*, Paris.

1950–6 Photographed extensively in Europe and Israel for various publications.

1951 Exhibited photographs in *Weltausstellung der Photographie*, Lucerne, Switzerland.

1954 Became President of Magnum Photos.

1955 Included photographs in the landmark exhibition *The Family of Man* at the Museum of Modern Art, New York.

1956 Died 10 November while covering Suez crisis. Gunned down by an Egyptian soldier while riding in a jeep driven by Jean Roy en route to cover an exchange of prisoners.

Phaidon Press Limited
Regent's Wharf
All Saints Street
London N1 9PA

Phaidon Press Inc.
180 Varick Street
New York NY 10014

www.phaidon.com

First published 2005
© 2005 Phaidon Press Limited

ISBN 0 7148 4276 1

A debt of gratitude is owed by the author
to Inge Bondi, for biographical information
on Seymour not obtained from family
sources, and Richard Whelan, for his book
Robert Capa, A Biography (1985). The author
is also grateful to Ben Shneiderman and
Helen Sarid for providing access to Seymour
research materials. This volume is dedicated
to Eileen Shneiderman, Seymour's sister,
who recently passed away, aged 96.

Designed by Pentagram
Printed in China